32489109006459
Klatt, Mary Beth.

687
KLA

Chicago's fashion
history, 1865-1945

$14.07

DATE DUE	BORROWER'S NAME	ROOM NO.

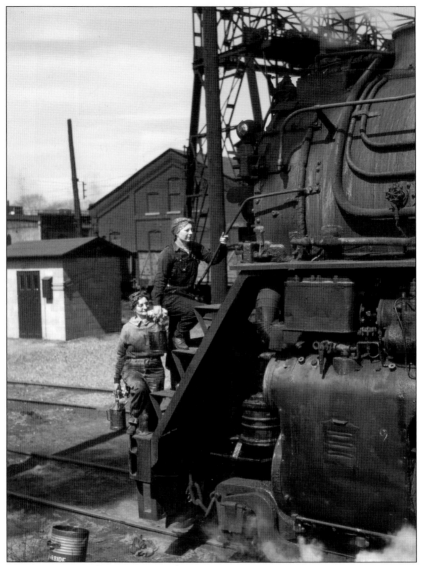

Two women wipers, Marcella Hart and Viola Sievers, of the Chicago Northwestern Railroad, step up on the steam engine to clean it up for its next trip in 1943. They are dressed in the workman's garb typical of the World War II era; both women have bandanas tied around their heads, a look that's often associated with the famous Rosie the Riveter poster of the time. One woman is wearing a lightweight denim shirt with a pair of men's overalls. Her colleague appears to be wearing a sweatshirt and a pair of denim jeans. Since there was a shortage of male workers in the United States during the war, these women were doing men's jobs. (Courtesy of the Library of Congress, LC-DIG-fsac-1a34804.)

ON THE COVER: This undated photograph, titled "Chicago Opera girls knit," shows a group of women knitting backstage, possibly in the 1920s. Women often knew how to knit and darn socks as early as age five and could often make simple garments by age eight using yarns purchased at department stores. (For more, see page 24.) (Courtesy of the Library of Congress, LC-DIG-ggbain-26139.)

IMAGES
of America

CHICAGO'S
FASHION HISTORY
1865–1945

Mary Beth Klatt

ARCADIA
PUBLISHING

Published by Arcadia Publishing
Charleston SC, Chicago IL, Portsmouth NH, San Francisco CA

Printed in the United States of America

Library of Congress Control Number: 2010920203

For all general information contact Arcadia Publishing at:
Telephone 843-853-2070
Fax 843-853-0044
E-mail sales@arcadiapublishing.com
For customer service and orders:
Toll-Free 1-888-313-2665

Visit us on the Internet at www.arcadiapublishing.com

To my best friend, Paulette Janine Ennis,
even though I'm a conservative and you're not, at least we can agree on
our passion for fashion and the importance of making dreams come true.

CONTENTS

ACKNOWLEDGMENTS

In no particular order, I would like to thank Paulette J. Ennis, Gerry Souter, Lori Klatt, Annie Logue, Rachel Weingarten, Margaret Littman, Kristine Hansen, Anita Bartholomew, Robert Case, the Rogers Park Historical Society, Beth Wilson, Heather Kenny, Maribeth Brewer, Kay Kuciak, Lynn Furge, Tom O'Keefe, William Cole, Brooke Vane, Rebecca Kussman, Julie Sturgeon, Veronica Hinke, Laura Laing, Melissa Basilone, Liz Levine, Lisa Bertagnoli, Holly Ocasio, Bev Bennett, Rachel Weingarten, and Gwen Moran.

INTRODUCTION

Chicago's contribution to the U.S. fashion scene is little known and often overlooked. Perhaps it has something to do with being located squarely in the middle of the country. The city, the third largest in the nation, certainly doesn't have the glitz of its larger cousin, New York City, or the Hollywood glow of Los Angeles.

What it lacks in sizzle, celebrities, and size, it makes up for with sheer ingenuity and Midwestern muscle. Chicago's fashion industry began in earnest in the aftermath of the Chicago fire in 1871 with the rebuilding of the city. Entrepreneurs, self-made millionaires, and immigrants, largely from Europe, all contributed to the city's style in their own way. The entrepreneurs made clothes from scratch and sold them from humble storefronts. Millionaires went to Europe to buy the best and brightest new suits, dresses, hats, and accessories and brought them back home, where they were instantly copied by local designers. Immigrants brought the clothing on their backs, which they wore as they hawked their wares on the streets.

Bertha Palmer, wife of businessman Potter Palmer, was a major influence in Chicago's fashion and social scene. She was one of the early Chicagoans who bought her wardrobe overseas, particularly in Paris, where she represented the United States at the World's Fair in 1900. She was the only woman on the commission for her country. Palmer also played a critical role in the World's Fair of 1893 in Chicago. An early supporter of women's achievements, she knew her attire would help accomplish her goals.

As a major player in international circles, Palmer knew the critical importance of the special occasion dress, which was usually long and made from the best fabrics such as silk shantung, velvet, satin, and taffeta. For decades, nearly every woman in every social class had at least one gown, however simple, for dancing, which was initially done at church socials, barn raisings, street parties, later in ballrooms, and eventually in dance halls and nightclubs. Yet there were dresses to be worn for other events, such as weddings and funerals. Extra details like lacework, beading, and ruching (a type of pleating) made these garments worth passing on to the next generation.

Likewise there were the everyday dresses worn for the office, factory, and housework. Through the early part of the 19th century, these too were long. Initially they were often custom made at home by skilled sewers, and later mass-manufacturing factories were built expressly for ready-to-wear clothes. As hemlines crept up, dresses became simpler, and designers such as aviator Amelia Earhart took note. The celebrity sold her line of clothing at Marshall Field's in 1934, introducing her concept of separates. Cotton was used in 80 percent of clothing during World War II; Chicagoans could order percale, gingham, chambray, and other dress and shirting fabrics by the yard through Sears, Roebuck and Company. Some garments were made from the new fiber rayon during this time; it made dresses less prone to wrinkles.

Hats were nearly as important as dresses. No woman, no matter how poor, would walk out the door without her hat—it just was not done. So there was always money set aside for this most important accessory. If a woman was especially skilled, she could make her own hat using

a piece of sisal shaped over a wood bowl and steamed into shape with a kettle. Others bought their hats at local shops or downtown on State Street. During the Victorian era, picture hats were popular to cover the upswept hairdo. While the wide-brim chapeau always remained in style, hats generally became smaller in scale as women moved to dresses with ankle to mid-calf hems and simpler hairstyles. When the close-fitting cloche became the statement hat of the 1920s flapper movement, the city's millinery industry was at full throttle launching the careers of Benjamin Greenfield and Charles James. By the 1940s, the city's reputation as the source for hats was solid with Greenfield selling his designs at the Drake Hotel on the north side and African American milliners selling theirs on the South Side, namely Forty-Seventh Street.

Hairstyles, naturally, were important, since they had to complement hats. Women used pins and straps to anchor their hats to their heads; they adjusted them just so they wouldn't destroy the curls they worked so hard to create. During the late 1800s, hair was always long and swept, during the day, into elegant coiffures with buns, coils, and careful curls. Later there was the "Gibson Girl," popularized by Charles Dana Gibson, which was a look that was all about a voluminous upswept style with tendrils of wispy ringlets. Shorter dos did not come into style until the 1920s with the film industry, which moved from New York to Chicago. Then stars such as dancer Irene Castle, actors Clara Bow, Colleen Moore, Louise Brooks, and others gave American women the courage to go to the barber and get their long locks cut. The severe bob gave way to longer and softer versions of the cut in the 1930s. Longer hair, always curled, became fashionable again in the 1940s; a perfect foil for the little cocktail hat, just tilted, which became the signature look of World War II.

Even teenage girls were most concerned about their hair, which they curled carefully overnight with rags, rollers, or the newfangled curling iron. They too wore hats, especially to church or synagogue, dance halls, and even an afternoon at the movies. Teenagers were always part of the workforce, but mass marketers began to target them as a group as early as the mid-1920s (Harold Lloyd in the silent film comedy *The Freshman* and Buster Keaton's *College*). Local clothier and big-band musician Harold C. Fox was partially credited for introducing the zoot suit, typified by high-waisted pants, a long jacket with padded shoulders, and wide lapel, which was a fad started by African Americans and picked up by white hep cats, often characterized as draft dodgers during World War II.

Pants, for the longest time, were exclusively for men. Women were forbidden to wear them in public. One rebellious suffragette wore a fitted pair for a Chicago parade, where she touched off a storm of controversy. Even after that event, women still could only wear trousers for sports (horseback riding, golf, and tennis) or leisure (a day in the country or a vacation at the beach), although an increasing number of them wore pants during World War II for their factory or military work. World War II proved to be the transition for denim pants; it started to become the fabric for after-work and play outfits and not always for machinists.

During the early 1940s, Chicago became better known as a fashion incubator. Mainbocher (Main Rousseau Bocher), who was born in Chicago and started a fashion house in Paris, made headlines for the wedding dress he designed in 1937 for the Duchess of Windsor. Benjamin Greenfield was in his prime with his delightful Bes-Ben hats, which were featured in *Life* magazine, including one trimmed with cigarette packages and another with a sponge and iced tea spoons. He trimmed gossip columnist Hedda Hopper's chapeau with razors for the premiere of the movie *The Razor's Edge*. By 1945, the "City of Big Shoulders" was a fashion scene to be reckoned with.

One

GETTING GUSSIED UP

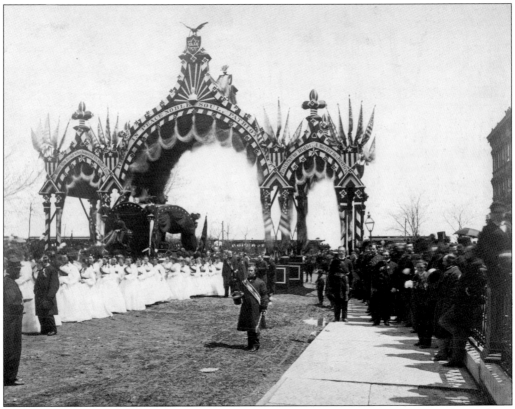

In 1865, women in white dresses accompany President Lincoln's hearse as it passes beneath an ornamental arch at Twelfth Street. These ladies are wear the dresses with corsets and crinolines, typical undergarments for the mid- to late 19th century. Wearing white for mourning was unusual, as black was considered more appropriate. Widows would mourn for two and a half years; black was a big part of their daily wardrobe during that period. (Courtesy of the Library of Congress, LC-DIG-ppmsca-19202.)

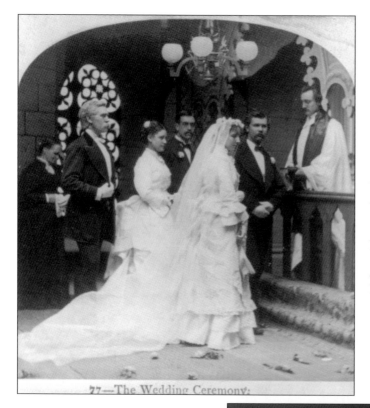

77—The Wedding Ceremony;

The bride looks stunning as she approaches the altar for her wedding, which took place between 1874 and 1889 and was documented by Chicago photography studio Melander. Both she and her matron of honor are wearing gowns with bustles, which were popular through the 1890s. The bride's resplendent outfit could have been imported in the post–Chicago Fire era, but she could have also hired a local modiste to do the handiwork. (Courtesy of the Library of Congress, LC-USZ62-63297.)

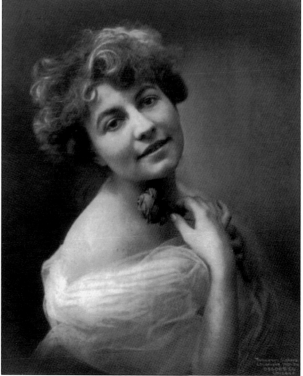

A young woman poses with a rose underneath her chin for this highly-stylized portrait printed in Chicago in 1901. Her hairstyle and décolletage are especially notable as her locks swirl into an upswept coiffure with her striking grey locks untouched. She is also wearing an extravagant off-the-shoulder tulle ball gown; in addition to tulle, chiffon, satin, and cotton were top fabric choices in the early 20th century. (Courtesy of the Library of Congress, LC-USZ62-80554.)

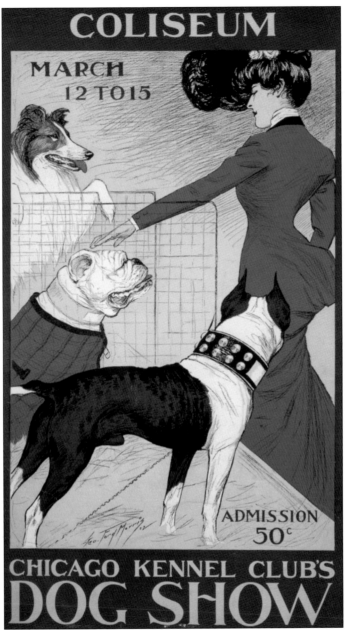

A woman wearing a long red suit dress with a black-and-white collar admires dogs in this 1902 Chicago Kennel Club's Dog Show poster made by George Ford Morris. The illustration of the bustle, an exaggerated fullness at the back of a woman's skirt, was particularly fascinating with its elaborate framework. The bustle was worn underneath a dress below the waist to keep the skirt from dragging. Heavy fabrics, such as brocade and velvet, were prone to pull down and flatten a skirt in the back; a bustle countered this tendency. By the early 20th century, the bustle was on its way out, because it was not compatible with the newly popular long corset. Bustles appeared again on some 1940s clothes; Christian Lacroix designed a knee-length dress with a pouf in the 1980s for Jean Patou. Now the word *bustle* is largely associated with moving energetically. (Courtesy of the Library of Congress, LC-USZC4-12528.)

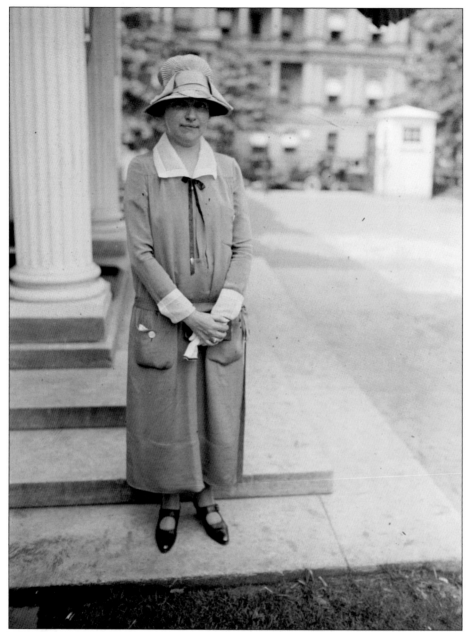

Judith C. Waller of WMAQ Radio in Chicago wears her best dress, hat, and gloves to the White House in 1924, just two years after she put the radio station on the air in 1922 as WGU. Known as the "First Lady of Radio," she revolutionized the industry from the beginning. In the early days, she filled in as an announcer and played music for listeners when talent was not available. She started baseball broadcasts after a friend complained that school kept him away from his favorite sport; the Chicago Cubs were the first team to have their games on the air. Waller also established the University of Chicago roundtable, the American Medical Association program, and many other public service broadcasts. She later published a book titled *Radio: the Fifth Estate*, a text about industry operations. Waller was also later awarded an honorary degree by MacMurray College in Jacksonville, Florida. (Courtesy of the Library of Congress, LC-DIG-npcc-26005.)

This unidentified Logan Square resident looks focused on her golf game. Women in the late 1920s wore dresses or breeches on the golf course. Merchandisers and pattern companies started making women's clothes strictly for the links. Knitters had an array of instructions on how to make golf sweaters and vests for men and women. However, there was not widespread interest in women's golf until after World War II. (Courtesy of Tom O'Keefe.)

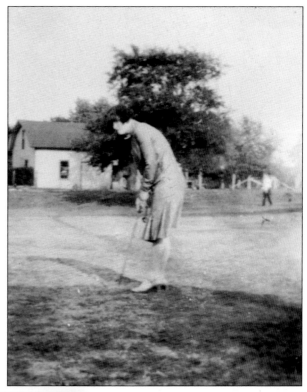

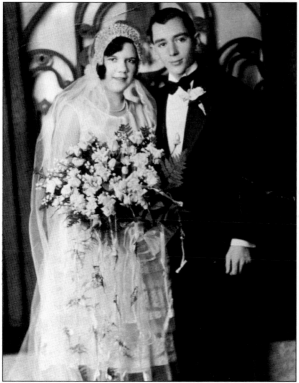

Sarah Damask, at her 1929 wedding to Harry Wagner, wears a beaded buckram coronet with a silk tulle veil that is longer than her tiered knee-length dress. She is holding a large and elaborate bouquet with bits of fern hanging delicately. Popular flowers during this period included orchids, calla lilies, and gardenias. Wedding dresses were often passed down in families and altered for the next generation's bride. (Courtesy of the Rogers Park Historical Society.)

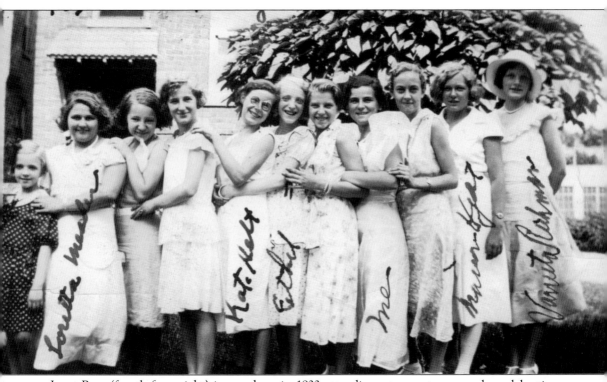

Janet Ross (fourth from right) is seen here in 1933 attending a tea party, a popular celebration during the Depression, held by her friend Ethel Pingels. The tea party was a way for a hostess to entertain at home without the customary maid helping out. The hostess would serve inexpensive foods such as dainty little sandwiches and tea. Women's clubs, whether they were dedicated to gardening, bridge, or hand sewing, experienced a revival during this period—a contrast to the individualism of the flapper era. Regardless of the purpose, all the women in these clubs would typically wear feminine dresses, and sometimes a hat and gloves, to these special occasions. Bobbed hair continued to be the style, although a little longer than what was common in the 1920s, perhaps because Americans wanted to conserve on their trips to the barber. The more ladylike haircut also could have been a reaction to the more severe masculine hairstyles of the 1920s. (Courtesy of Kay Kuciak.)

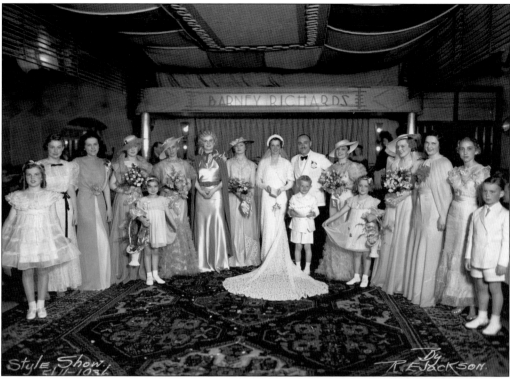

Fashion shows were the rage in 1936, even in neighborhoods such as Rogers Park. Sam Diamond, owner of Della Frocks on Howard Street, proudly poses with his bride-show models at Limehouse Café. The "bride" is wearing an Alençon lace gown; her maid of honor also has a discrete panel of Alençon lace in a skirt panel on her gown. Extravagant hats for the bridesmaids were popular at wedding ceremonies through the 1970s. The same model also poses inside Della Frocks in another photograph. While the model's ensemble is glamorous, it is modest and appropriate for a church wedding. The leg-of-mutton sleeves and jewel neckline are typical of mid-Depression attire. The model's silk tulle veil, anchored by a buckram coronet tiara strapped under the chin, does not skim the floor like its Depression-era counterparts. (Courtesy of the Rogers Park Historical Society.)

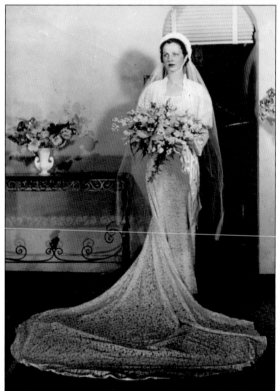

15

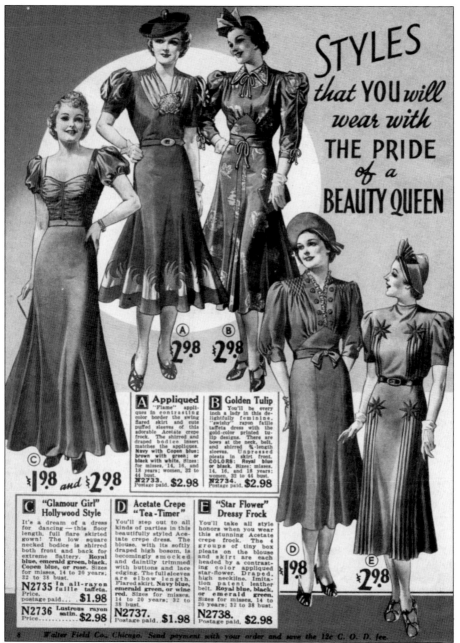

STYLES
that YOU *will*
wear with
THE PRIDE
of a
BEAUTY QUEEN

A Appliqued
"Flame" appliques in contrasting color border the swing flared skirt and cute puffed sleeves of this adorable Acetate crepe frock. The shirred and draped bodice insert matches the applique. Navy with Copen blue; brown with green; or black with white. Sizes for misses, 14, 16, and 18 years; women, 32 to 44 bust.
N2733. $2.98
Postage paid.

B Golden Tulip
You'll be every inch a lady in this delightfully feminine. "swishy" rayon faille taffeta dress with the gold-color printed tulip designs. There are bows at the neck, belt, and shirred ¾-length sleeves. Unpressed pleats in skirt front. COLORS: Royal blue or black. Sizes: misses, 14, 16, and 18 years; women, 32 to 44 bust.
N2734. $2.98
Postage paid.

C "Glamour Girl" Hollywood Style
It's a dream of a dress for dancing — this floor length, full flare skirted gown! The low square necked bodice is shirred both front and back for extreme flattery. Royal blue, emerald green, black, Copen blue, or rose. Sizes for misses, 32 to 38 bust.
N2735 in all-rayon faille taffeta.
Price, postage paid... $1.98
N2736 Lustrous rayon satin.
Price............ $2.98

D Acetate Crepe "Tea-Timer"
You'll step out to all kinds of parties in this beautifully styled Acetate crepe dress. The blouse, with its softly draped high bosom, is becomingly smocked and daintily trimmed with buttons and lace edging. The full sleeves are elbow length. Flared skirt. Navy blue, emerald green, or wine red. Sizes for misses, 14 to 20 years; 32 to 38 bust.
N2737.
Postage paid. $1.98

E "Star Flower" Dressy Frock
You'll take all style honors when you wear this stunning Acetate crepe frock. The 4 groups of tiny box pleats on the blouse and skirt are each headed by a contrasting color appliqued star-flower. Draped, high neckline. Imitation patent leather belt. Royal blue, black, or emerald green. Sizes for misses, 14 to 20 years; 32 to 38 bust.
N2738.
Postage paid. $2.98

8 *Walter Field Co., Chicago. Send payment with your order and save the 12c C. O. D. fee.*

A young Chicago woman's wardrobe was hardly complete if she did not have at least one fancy gown in her closet, one that was suitable for dancing. Local mail-order house Walter Field Company had just the dress (above left) at an affordable price in 1938. The "Glamour Girl" had Hollywood style, and it was available in an array of colors in all-rayon faille taffeta for ages 14 to 20 years. The Lindy Hop was especially popular with teenagers during this period; they would roll up the rug in the living room at home for dancing. America's only folk dance was even featured on the cover of *Life* magazine in 1943. If teens dressed up to go out on the town for dancing, they went to places such as the Aragon Ballroom, the Edgewater Hotel, or even the Willowbrook Ballroom in Willow Springs. (Author's collection.)

A Chicago carpenter's wife, Alice Belester, wears a hat and her finest dress in 1939 while telling the Monopoly Committee in Washington, D.C., what she thinks of product advertising targeted to housewives. Here she is noting that some ads were useless because they failed to mention the grade and weight of the material used. She is using an advertisement for dresses to make her point. Belester's own outfit is compelling; her dress, likely a wool crepe, looks quite fancy with its white satin collar and small rhinestone clips. The satin collar could have been part of a dickey, which is a removable, false shirtfront. The dickey became one of the signature accessories of the 1930s and 1940s. The shirtfront conserved resources, and it was relatively inexpensive. It made it easy for women on a budget to add variety to their wardrobes. Sewing, knitting, and crochet patterns for dickeys were abundant during this period. (Courtesy of the Library of Congress, LC-DIG-hec-26663.)

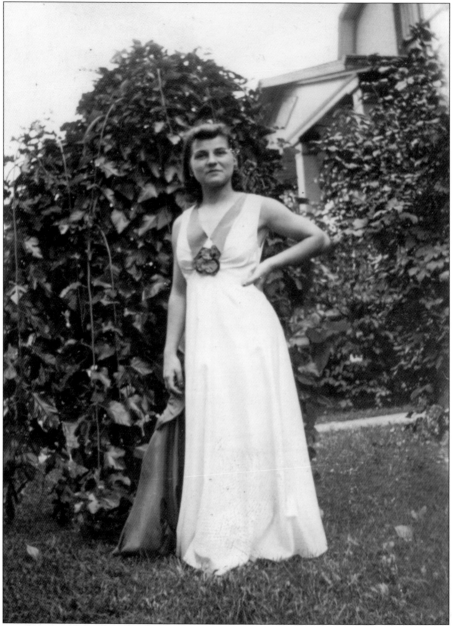

With her hand on her hip, Janet Carlson shows off her stylish gown, possibly made from rayon taffeta, which differed from what was trendy in Paris in the late 1930s and early 1940s. When the United States entered World War II, the fashion scene turned its focus to New York and Chicago, as Americans sought to do their patriotic duty and support local designers. Marshall Field's did its part by selling a hat by well-known New York milliner Lily Daché. Locals also sought out the hats trimmed by designer Benjamin Greenfield, who had a shop in the Drake Hotel and worked in tandem with his sister Bessie. Claire McCardell, also in New York, started to become well known during this period for the American look—functional and affordable sportswear. Her trademark style would flourish after 1945. Her designs became so popular that she even had a line of sewing patterns. (Courtesy of Kay Kuciak.)

Rose Neudert holds her daughter Lorraine for a Chicago backyard portrait in 1939 at her Humboldt Park home. She is wearing a lightweight white dress with tortoiseshell buttons, a look she finishes off with perfectly coiffed hair and a pair of matching peep-toe sandals with perforations on the vamp. Neudert worked in alterations during her career; she was an expert at hand sewing buttonholes. (Courtesy of Lorraine Klatt.)

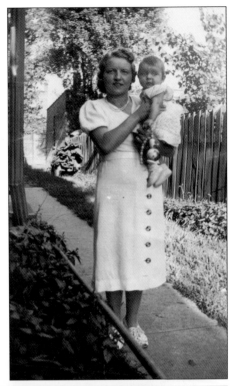

This model poses in a 1940s gown at Della Frocks in Rogers Park. With the United States at war, fashions became frugal. A ruffle of self-fabric, apparently clipped with pinking shears, was used to trim the hem and florets on the bodice and sleeves—unusual during a time when finished edges were the norm. Owner Sam Diamond operated Della Frocks for 35 years; he died in 1970. (Courtesy of the Rogers Park Historical Society.)

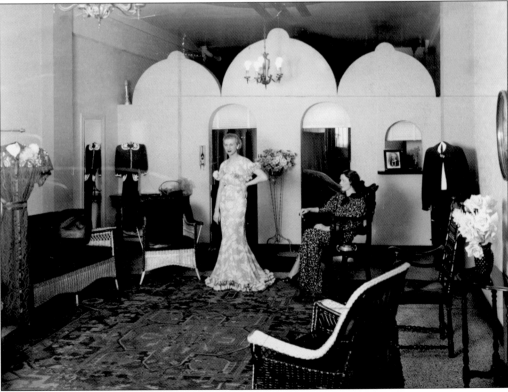

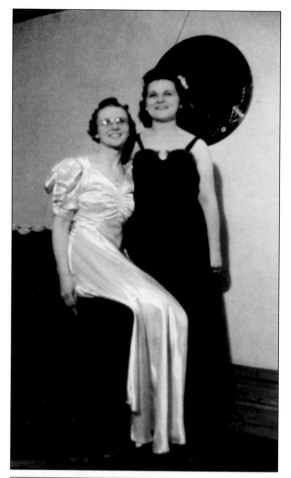

Janet Carlson (right) and her friend Dot Kanzer are dressed up for a night on the town with their husbands sometime in the early 1940s. If it was cool outside, the women likely wore furs, which they purchased in Chicago. The city was still a major distribution center during this period, a holdover from the days when trappers sold directly to suppliers. (Courtesy of Kay Kuciak.)

World War II weddings were simple affairs, and the October 1942 ceremony for Vince Sosnowski and his wife (left) was no exception. Suits for the bride and the groom were often the wedding attire during this period. The Chicago newlyweds pose with another unidentified couple for this photograph. Corsages took center stage instead of wedding bouquets during the war years. (Courtesy of Kay Kuciak.)

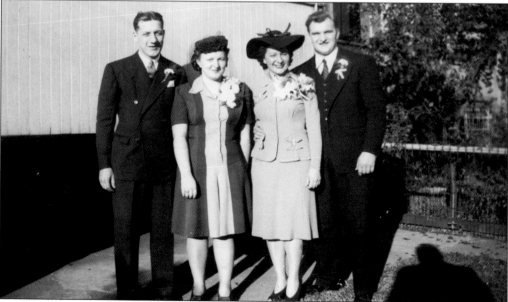

Two

MY CLOSET, MY DRESSES

This 1905 photograph shows State Street, where fashions for both men and women could be found at department stores lining the streets. Marshall Field's and Carson Pirie Scott were two stores where up-to-the-minute clothes could be found. Bowler hats for the men and long skirts for the ladies were considered de rigueur. Canvas awnings kept the stores cool in the days before air-conditioning. (Courtesy of the Library of Congress, LC-USZ62-101147.)

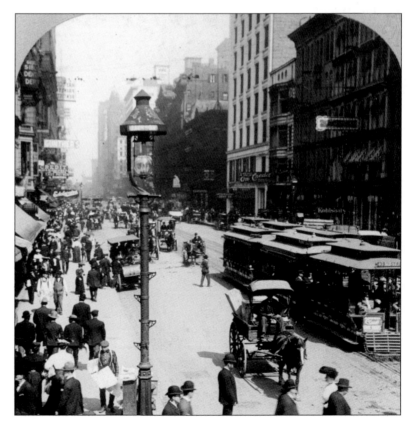

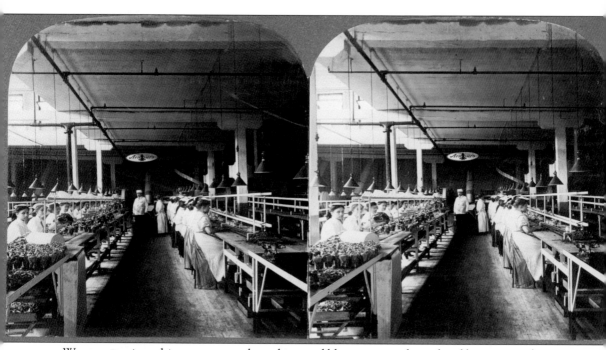

Women wearing white aprons over long skirts and blouses are packing sliced bacon into glass jars in the city's Union Stockyards, where pigs, cattle, and sheep were slaughtered and processed for various byproducts including soap and butter, in 1909. The local stockyards were a major source of work for many Chicagoans during the early 20th century. The treatment of the city's female factory workers was famously chronicled by Theodore Dreiser in *Sister Carrie*. Women did work in other types of factories, including the manufacturing industry. The degrading treatment and unsafe conditions would lead to the women's rights movement. Empowered by Hull House founder Jane Adams, 5,000 suffragettes marched in the rain in Chicago to influence a Republican party convention in 1916. Most wore customary garb, such as skirts, dresses, gloves, and hats; however, at least one suffragette wore pants, causing a scandal. (Courtesy of the Library of Congress, LC-USZ62-107064.)

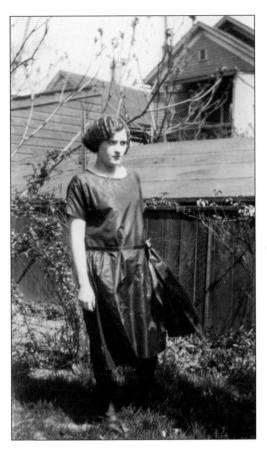

Simplicity was the one of the hallmarks of the post–World War I era. An unidentified Logan Square resident poses in 1919 wearing a dress with slight ruching down the center of the sleeves and a boatneck collar. Her hair is cut short, resembling dancer and film star Irene Castle's hairstyle at the time. The same woman stands below with an unidentified friend, also possibly in 1919 in a part of undeveloped Chicago. While many women continued to wear corsets, the relaxed fit with a virtually nonexistent waistline did not require them. With the new silhouette, designers and manufacturers turned their attention to interesting trims. (Courtesy of Tom O'Keefe.)

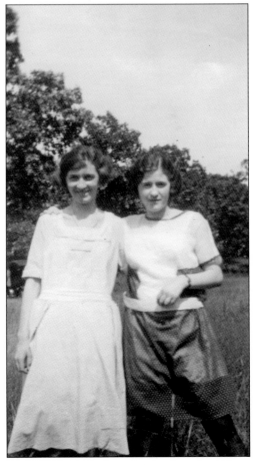

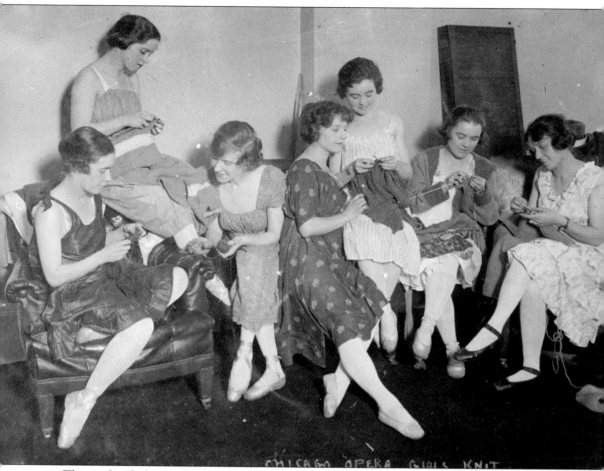

This undated photograph, titled "Chicago Opera girls knit," shows a group of women knitting backstage. The bobbed hairstyles and apparel would seem to indicate this photograph was taken at least in the 1920s. Women often knew how to knit and darn socks as early as age five and could often make simple garments by age eight using yarns purchased at department stores. Mothers often taught their daughters the basic skills of casting on and binding off, although there were men who knew how to knit, too. Soldiers on the frontlines would sometimes remake socks sent to them. Skilled knitters also knew how to darn or repair holes on socks using a wooden egg. Darning would remain popular and practical through the early 1960s, when it became cheaper and easier just to replace socks with new store-bought ones. Knitting remains a popular way to pass time backstage. (Courtesy of the Library of Congress, LC-DIG-ggbain-26139.)

A 1922 ad for the now-defunct Rip Easy Company in Waterloo, Iowa, titled, "A group of Chicago's famous models. Ripping is a pleasure with Rip-Easy," shows six Chicago women sitting inside a home ripping stitches from garments. All the women sport permed bobs, a fad during the era. In the days before ready-to-wear clothing was easily accessible, it wasn't uncommon for women to remake garments. (Courtesy of the Library of Congress, LC-USZ62-55807.)

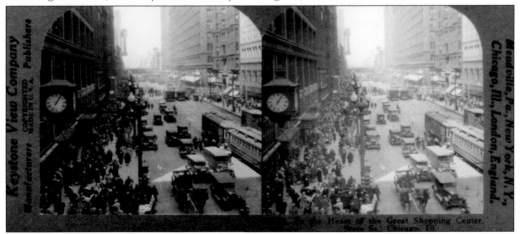

State Street in 1928 teems with streetcars, automobiles, and throngs of passersby on this stereo-card view of the famed shopping district. Marshall Field's, seen here with its landmark clock, was a popular shopping destination at the time. As a tradition, shoppers continue to meet under the clock; Macy's now owns the Marshall Field's building. (Courtesy of the Library of Congress, LC-USZ62-57354.)

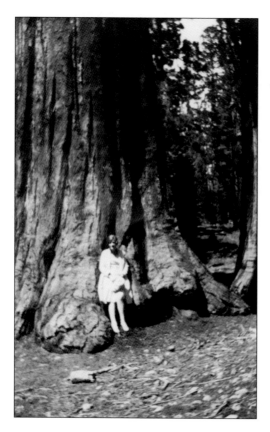

Dwarfed by California's redwood trees at left, an unnamed Logan Square resident shyly poses for a photograph sometime during 1929 wearing a duster (a long overcoat) with deep pockets over a dress. As cross-country travel became more popular, dusters for men and women were a way to keep their clothes free from soot and grime. As cars became enclosed, there was less of a need for head-to-toe protection from dust. In another shot from the same trip, the same Logan Square resident sits on a redwood tree trunk in California apparently holding her cloche. The cloche was a universal hat for women during the 1920s; it virtually disappeared during the 1930s when women began to wear their hair longer. (Courtesy of Tom O'Keefe.)

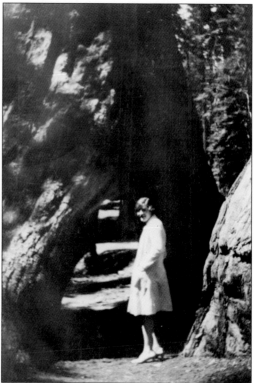

The undefined waistline was still popular in 1929, when this photograph of an unidentified Logan Square resident was taken in Humboldt Park. Chicago's fashions were very different from Paris, where designers were already showing longer skirts and higher waistlines. Worldwide, undergarments were also moving in a new direction from the popular all-in-one lingerie to separate panties and brassieres. The corset would return in the 1930s as the girdle. (Courtesy of Tom O'Keefe.)

The drop-waist dress, especially popular during this 1920s photograph, was carried over into the early 1930s. Alice and Wally Carlson pose for a high school graduation picture in Chicago sometime during the 1930s. During this period, Sears, Roebuck and Company sold Hooverettes, which were inexpensive, simple, wraparound dresses. They were reversible, so the whole dress could be flipped inside out for a different look. (Courtesy of Kay Kuciak.)

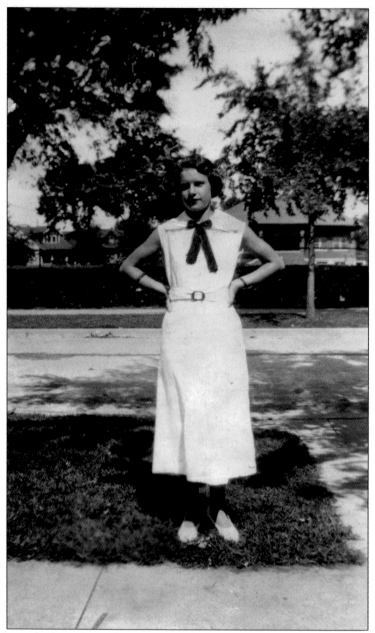

The white sailor-style dress, shown here on Janet Carlson in Gladstone Park, was a popular, sporty look in the early 1930s. The straight lines and loose fit were carried over from the 1920s. Variations of this dress, especially with a pant-like skirt, were popular for tennis and bicycle riding. They were usually made from lightweight fabrics, such as cotton, gingham, pique, or linen, for the summer and denim, corduroy, and other heavier dress fabrics during the fall; they were worn with sneakers or two-tone saddle shoes. Advance, Anne Adams, DuBarry, Excella, Hollywood, Superior, and scores of other now-defunct companies sold sewing patterns for the dresses with the split-skirt sometimes known as the culotte dress. The culotte dress would later help make pants acceptable sports attire for women. Ginger Rogers, Katharine Hepburn, Carole Lombard, and other movie stars made the boyish look trendy during the Depression. (Courtesy of Kay Kusiak.)

Chicagoan Janet Carlson wears a dress in the early 1930s with a ruffled double collar and flutter sleeves. This attire was reminiscent of the dresses that actors Claudette Colbert and Myrna Loy wore in the movies during this time. Ruffles and frills gave garments a femininity that was missing from 1920s dresses. (Courtesy of Kay Kusiak.)

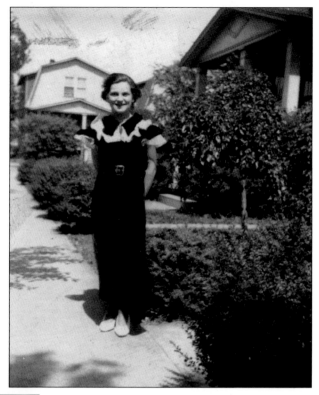

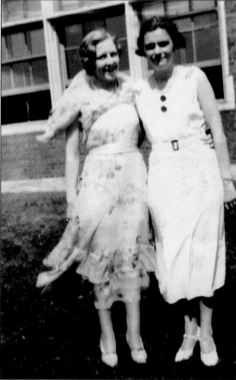

The tiered dress was a popular afternoon outfit in 1933, when this photograph of teachers Mrs. Dahlin and Miss Ward was taken at a Hitch School graduation. A floating romantic dress paired with a big straw hat was ideal for a tea party. The white cotton dress worn by Miss Ward was not nearly as dreamy, but it was practical. These cotton dresses were sold with matching buttons and buckles. (Courtesy of Kay Kuciak.)

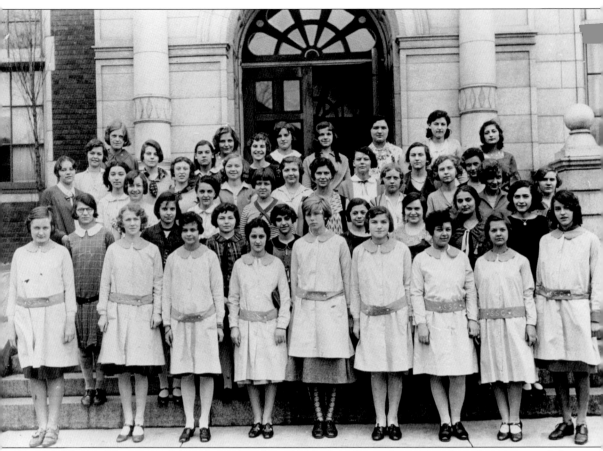

The smock was a popular garment in the 1930s for women, as they covered up their dresses while working. Here a class of girls wears smocks with embroidered initials on Peter Pan collars in front of Sacred Heart School in 1933. Smocks were popular for cooking classes during the early 20th century. The DuBarry pattern company sold a pattern for a smock that had a Bertha collar, a bow, shirring, pockets, and cuffed, gathered sleeves during this period. These smocks, an alternative to aprons, were made in an array of light fabrics ranging from silk to gingham to batiste. Fancier ones had smocking, a type of decorative hand stitching in elaborate honeycombed designs, across the yokes or on the cuffs and a box pleat on the back. Similar smocks are worn by many older Hispanics today for cooking at home. (Courtesy of the Rogers Park Historical Society.)

The two-piece sweater dress, shown here on Janet Carlson's unidentified friend (left), was popular in 1935 when this picture was taken. A woman who was handy with the knitting needles could find patterns for this kind in *Handicrafter* magazine; the best of these were in the cutting-edge *Minerva*, which took its cue from fashion designers overseas. Yarn for projects could be purchased at Woolworth's and other stores. (Courtesy of Kay Kuciak.)

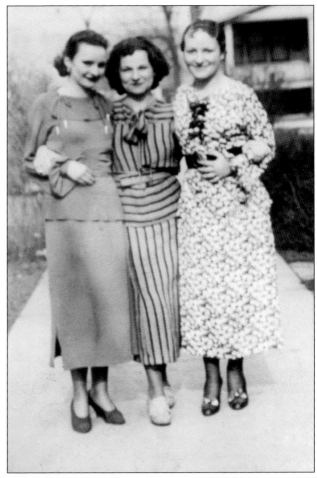

Sam Diamond, owner of Della Frocks at 1640 West Howard Street in Rogers Park, stands outside of his store in this 1935 photograph. Della Frocks, which was near a depot on the North Shore rail line, appealed to women who didn't want to travel downtown to shop. In addition to dresses, Diamond also sold hats. (Courtesy of the Rogers Park Historical Society.)

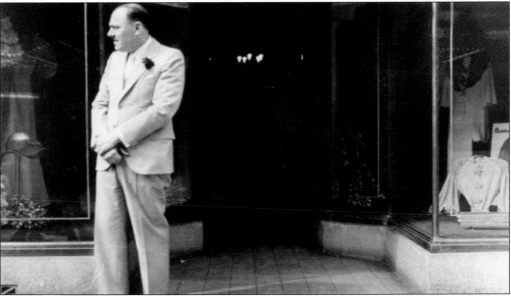

Janet Ross (second from the left), with friends on graduation day at Hitch School in the mid-1930s, wears a double-breasted white dress that resembles the everyday garments worn by women in nursing and the food industries from the 1930s through the 1950s. Ross's dress had a belt attached with buttons, a popular embellishment through the 1940s. Spectator shoes, like those on Ross's unidentified female friend, were introduced in the 1920s. Intended for men and women, the two-tone pump was frequently made in contrasting colors of navy, black, and red with a white background. Extra sewed-on pieces at the toe and the heel sometimes were perforated and pinked at the edges. They became popular dress-up shoes after the Duke of Windsor wore them. Spectator shoes were popular through the 1950s and were revived again during the 1980s, the 1990s, and the early 21st century. (Courtesy of Kay Kuciak.)

Separates took off and became popular beginning in the 1930s if this group photograph of students posing outside of Schurz High School in May 1936 is any indication. The unidentified woman on the left is wearing a bolero jacket over her kick-pleat dress, which has a belt and six matching buttons on the skirt. Another unidentified girl is wearing a short-sleeve sweater with a slim skirt—a sporty ensemble suitable for a student. (Courtesy of Kay Kuciak.)

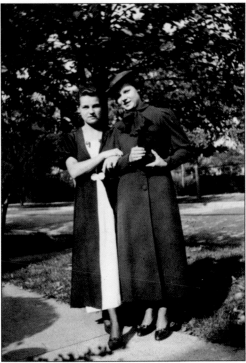

Dresses and coats nearly grazed the ankles in 1936 as shown in this photograph of Janet Ross (left) and her neighbor Bebe. Short sleeves, such as those on Ross's dress, were full; long ones on Bebe's coat had a leg-of-mutton styling. Tartan tam o'shanters (tams), such as the one Bebe is wearing, were popular; they were one of the military influences during that time. (Courtesy of Kay Kuciak.)

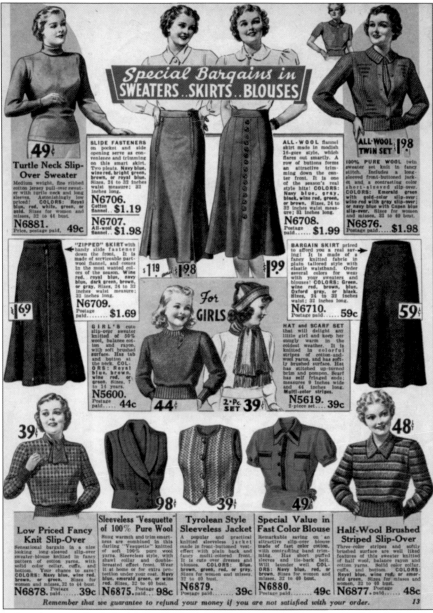

Special Bargains in SWEATERS..SKIRTS..BLOUSES

49¢

Turtle Neck Slip-Over Sweater

Medium weight, fine ribbed cotton jersey pull-over sweater with turtle neck and long sleeves. Astonishingly low priced! COLORS: Royal blue, red, white, green, or gold. Sizes for women and misses, 32 to 44 bust.

N6881.
Price, postage paid..... 49c

SLIDE FASTENERS on pocket and side opening serve as convenience and trimming on this smart skirt. Two pleats. Navy blue, wine red, bright green, brown, or royal blue. Sizes, 24 to 32 inches waist measure; 32 inches long.

N6706. Cotton flannel **$1.19**
N6707. All-wool flannel **$1.98**

ALL-WOOL flannel skirt made in modish 16-gore style, which flares out smartly. A row of buttons forms an attractive trimming down the center front. It is one of the season's real style hits! COLORS: Navy blue, gray, black, wine red, green, or brown. Sizes, 24 to 32 inches waist measure; 31 inches long.

N6708.
Postage paid..... **$1.99**

ALL-WOOL TWIN SET $1.98

100% PURE WOOL twin sweater set knit in fancy stitch. Includes a long-sleeved front-buttoned jacket and a contrasting color short-sleeved slip-over. COLORS: Emerald green with gold-color slip-over; wine red with gray slip-over; or navy blue with Copen blue slip-over. Sizes for women and misses, 32 to 40 bust.

N6876.
Postage paid..... **$1.98**

$1.19 **$1.98** **$1.99**

$1.69

"ZIPPED" SKIRT with handy slide fastener down the front. It is made of serviceable part-wool flannel, and comes in the most wanted colors of the season. Wine red, royal blue, navy blue, dark green, brown, or gray. Sizes, 24 to 32 inches waist measure; 32 inches long.

N6709.
Postage paid..... **$1.69**

For GIRLS

GIRL'S cute slip-over sweater knitted of 50% wool, balance cotton and rayon, with soft brushed surface. Has tab and button at the neck. COLORS: Royal blue, brown, wine red, or green. Sizes, 7 to 14 years.

N5600.
Postage paid..... **44c**

44¢

2-Pc SET 39¢

HAT and SCARF SET that will delight any little girl and keep her snugly warm in the coldest weather. It is knitted in colorful stripes of cotton-and-wool yarns, and has softly brushed surface. Hat has stitched up-turned brim and pompon. Scarf has self fringed ends; measures 9 inches wide and 44 inches long. Multi-color stripes.

N5619.
2-piece set..... **39c**

BARGAIN SKIRT priced to afford you a real saving! It is made of a fancy knitted fabric in plain tailored style with elastic waistband. Order several colors for wear with your sweaters and blouses! COLORS: Green, wine red, brown, blue, Oxford gray, or black. Sizes, 24 to 32 inches waist; 32 inches long.

N6710.
Postage paid..... **59c**

59¢

39¢

Low Priced Fancy Knit Slip-Over

Sensational bargain in a nice looking long-sleeved slip-over sweater-blouse knitted in fancy pattern of cotton yarns, with solid color collar, cuffs, and bottom. Your chance to save! COLORS: Navy blue, wine red, brown, or green. Sizes for women and misses, 32 to 44 bust.

N6878.
Postage paid..... **39c**

Sleeveless "Vesquette" of 100% Pure Wool

98¢

Snug warmth and trim smartness are combined in this darling "Vesquette" knitted of soft 100% pure wool yarns. Sleeveless style, with shawl collar and double-breasted effect front. Wear it at home or for extra protection under your coat. Navy blue, emerald green, or wine red. Sizes, 32 to 40 bust.

N6875.
Postage paid..... **98c**

Tyrolean Style Sleeveless Jacket

39¢

A popular and practical knitted sleeveless jacket made in front-buttoned vest-effect with plain back and fancy multi-colored front. It is cute over dresses and blouses. COLORS: Blue, brown, green, red, or gray. Sizes for women and misses, 32 to 40 bust.

N6879.
Postage paid..... **39c**

Special Value in Fast Color Blouse

49¢

Remarkable saving on an attractive slip-over blouse made of fast color cotton, with contrasting band trimming. Has short puffed sleeves and tie-back belt. Will launder well. COLORS: Navy blue, red, or brown. Sizes for women and misses, 32 to 40 bust.

N6880.
Postage paid..... **49c**

Half-Wool Brushed Striped Slip-Over

48¢

Three-color stripes and softly brushed surface are well liked features of this sweater knitted of half wool, balance rayon and cotton yarns. Solid color collar, cuffs, and bottom. COLORS: Royal blue, wine red, or emerald green. Sizes for misses and women, 32 to 40 bust.

N6877.
Postage paid..... **48c**

Remember that we guarantee to refund your money if you are not satisfied with your order.

13

Turtlenecks, skirts with slide fasteners (later called zippers), "vesquettes," and slip-overs were novelties on the rise for the Chicago woman looking to dress stylishly in 1938 if this Walter Field and Company catalog is any sign. While most of the items offered here were either 100 percent wool or cotton, rayon was beginning to become more acceptable. Note the twin set, a cardigan and a matching pullover sweater, which was an early incarnation of this popular apparel. The catalog version (upper right) had art deco motifs on it. During World War II, the set tended to be boxy and plain with a grosgrain button band. In the late 1940s, it became more fanciful with the Fair Isle pattern knitted around the collar. During the 1950s, there was an explosion of different types of twin-set knitting patterns published by Beehive, Fleisher's, Hiawatha, and other companies. The classic twin set, as worn by actors Grace Kelly and Marilyn Monroe, tended to be knitted in cashmere or wool and worn with a string of pearls. (Author's collection.)

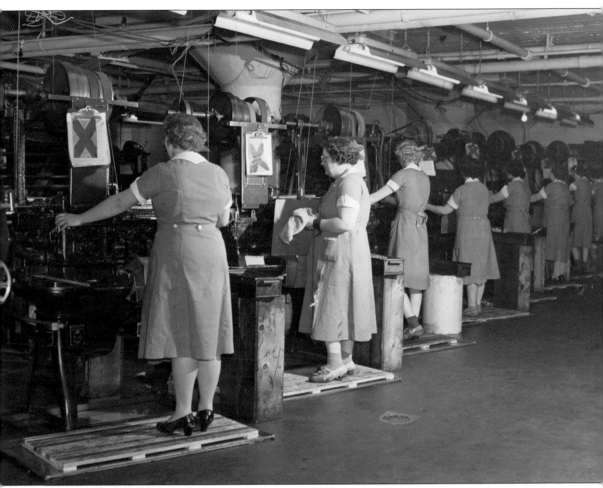

These factory workers were allowed to wear street shoes with their uniforms, a contrast to the well-known Rosie the Riveter poster that showed an illustration of a woman rolling up her sleeves and a red bandana on her head. Everything from stockings with back seams and dressy pumps to ankle socks with saddle shoes was permitted, as this Office of War Information picture taken in 1942 demonstrates. Women did not even necessarily have to cover their hair on the job. An accompanying photograph caption reads, "Sharp eyes and agile fingers make these young women ideal machine operators. They're conditioning and reshaping milling cutters in a huge Midwest drill and tool company, Republic Drill and Tool Company, Chicago, Illinois." (Courtesy of the Library of Congress, LC-DIG-fsa-8e11166.)

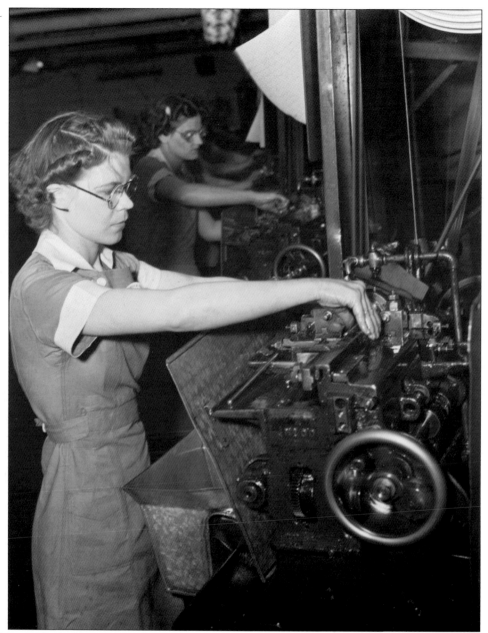

Women who had been waitresses, saleswomen, or teachers worked in factories such as Republic Drill and Tool Company during World War II. At Republic, they were producing tools and high-speed twist drills for weapons with little previous experience. In this particular 1942 picture, an unidentified Chicago woman works at a cutoff machine. She was apparently 1 of 1,000 women at this factory, and the only two men in the shop toiled in the heat-treating department in 1942. Women also took over another male-dominated industry—newspapers—while men fought the war overseas. Photographer Ann Rosener snapped this picture as part of a series for her job with the government; World War II made other female photojournalists famous, including Dorothea Lange and Claire Booth Luce. Women would pave the way for other minorities to become journalists and photographers after the war concluded. (Courtesy of the Library of Congress, LC-DIG-fsa-8e11162.)

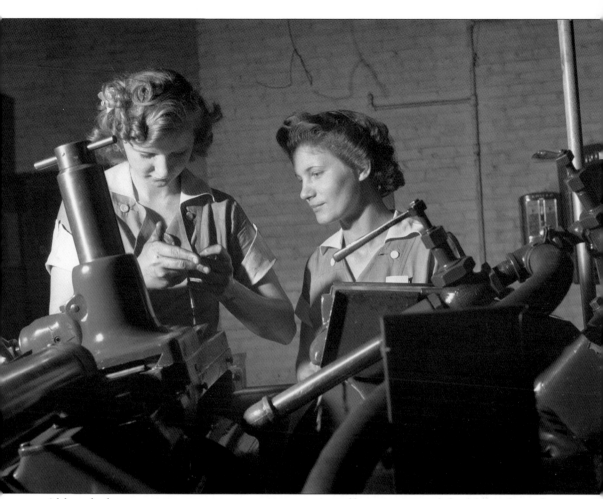

Although these two women are not wearing any type of hair covering while they work on the job at Republic Drill and Tool Company in 1942, many women in the defense industry wore some kind of hat for hazardous jobs. Often it was the bandana, but sometimes it was the snood, which actually became a popular way to dress up coiffures off the clock. While the snood dates back to the Middle Ages, it became part of a revival in the 1860s and then trendy again in the 1940s. Knitting and crochet patterns were available to make snoods in cotton and wool yarns to suit the season. Celebrities in Hollywood were photographed wearing snoods embellished with rhinestones and pretty ribbons. New York milliner Lily Daché made them into fashion statements, which were featured on the cover of *Vogue* magazine in 1942. (Courtesy of the Library of Congress, LC-USE6-D-0057190.)

Short-sleeve dresses with hems skimming the knee were trendy in 1945 when this photograph was taken in Chicago's Gladstone Park neighborhood. By this time, long bias-cut dresses, which required extra yardage, were out of style. The flower appliques on Irene Carlson's dress (right) and the chevron on her unidentified friend's outfit were some other thrifty ways to individualize attire during World War II, when fabric was rationed. Shoulder pads in women's dresses, sweaters, and jackets became stylish and would remain in vogue through 1949. Shoes went through their own evolution during this period. While these two women are wearing pumps, as many of their peers did during that time, leather shortages led manufacturers to experiment with elevated platform shoes with cork and wood soles. Sears, Roebuck and Company; Montgomery Ward; and other local department stores sold these trendy shoes. (Courtesy of Kay Kuciak.)

Three

IN THE DETAILS,
THE CHICAGO WAY

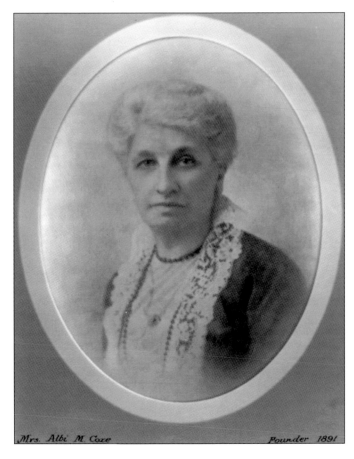

Women during the Victorian era often did not wear makeup. An older woman during the Victorian era, such as Albi M. Coxe, founder of the Rogers Park Woman's Club in 1891, probably powdered her face at the most. For years, lipstick and rouge were only used by prostitutes. Any time a woman went outside, she wore a hat to shield her face from the sun. (Courtesy of the Rogers Park Historical Society.)

Mrs. Albi M. Coxe Founder 1891

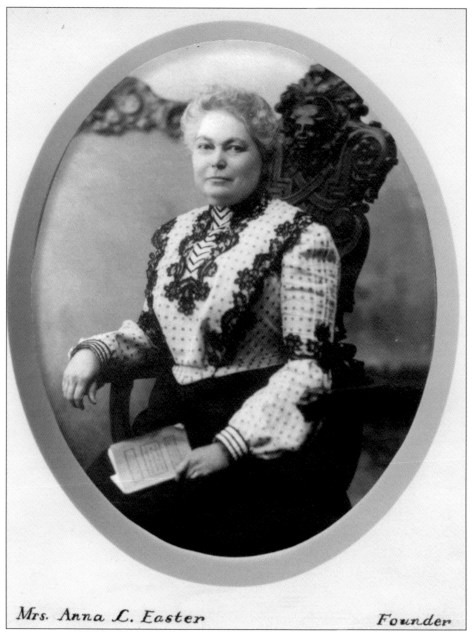

Mrs. Anna L. Easter *Founder*

A striking fitted blouse with a chevron-striped neck piece embellished with black lace is the star in this photograph of Anna L. Easter, a founder of the Rogers Park Woman's Club in 1891, a prominent community organization. The group started with an initial membership of 10 women. In 1894, the club opened a library and reading room; members were the librarians, and locals donated books for the shelves. That room would later become a branch of the Chicago Public Library. The club was also responsible for a domestic science class for residents and the Senn High School lunchroom. The club's building, which was constructed in 1916, was on the corner of Estes and Ashland Avenues; the organization operated in this facility for 70 years. By the early 1940s, when the group had more than 900 members, it was the center for Red Cross work. (Courtesy of the Rogers Park Historical Society.)

Victorian women, such as Lida D. Thorogood, a charter member of the Rogers Park Woman's Club in the 1890s, aimed for a natural look. Tweezing eyebrows wouldn't become more popular until silent-film stars started fiddling with their brows in the 1920s. Women during this period counted on accessories such as little earrings and a pretty fichu, a triangular scarf, to add drama around their faces. (Courtesy of the Rogers Park Historical Society.)

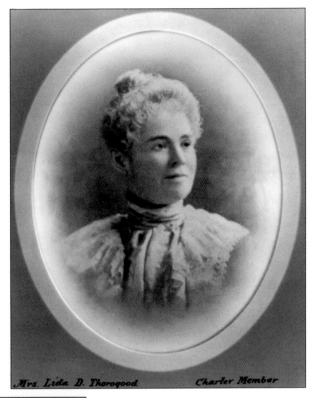

Mrs. Lida D. Thorogood *Charter Member*

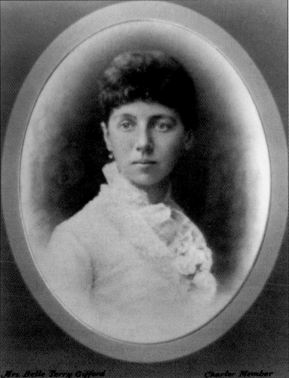

Mrs. Belle Terry Gifford *Charter Member*

Also a charter member of the Rogers Park Woman's Club in 1891, Belle Terry Gifford probably counted on a curling iron heated on the stove or rag curlers to shape her short bangs; she might have used a hairnet to keep her curls intact. Women during this era worked hard to keep their hair sleek, as any stray locks were considered vulgar. (Courtesy of the Rogers Park Historical Society.)

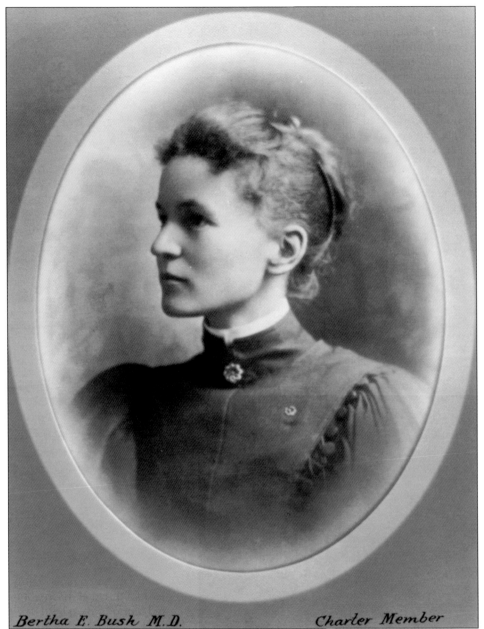

Bertha E. Bush M.D. *Charter Member*

Another charter member of the Rogers Park Woman's Club in 1891, Bertha E. Bush, M.D., was an accredited physician during a period when there were few women in the field. She appears to be wearing a pin on her lapel, perhaps showing her membership in a medical society. Interestingly, she has buttons on the sleeve seams of her blouse, possibly for quick removal to perform her duties. Bush could have received her medical degree in Chicago. Emily Blackwell, the sister of Elizabeth Blackwell, the first woman in the United States to get a medical degree, was admitted to Rush Medical College in 1852. She had applied to 11 schools before she received acceptance. By the early 20th century, most female physicians had private practices working with women and children patients or they worked on hospital staffs. In 1901, records show Bush reported on a case to the Chicago Pathological Society. (Courtesy of the Rogers Park Historical Society.)

Chicago-raised American actor and singer Lillian Russell (1861–1922) holds a fan in this 1893 portrait. Here the fan is used as a prop, but it was considered a major part of courtship during the Victorian era. How a woman held her fan indicated to prospective suitors whether or not she was interested in them. The bouffant sleeves and the background of roses were over the top, even for the time. (Courtesy of the Library of Congress, LC-USZ62-58386.)

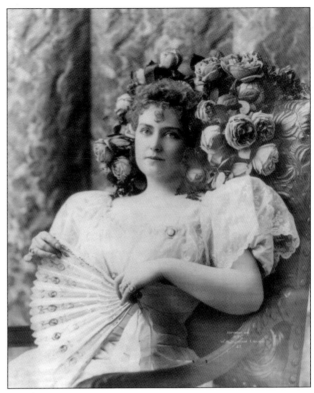

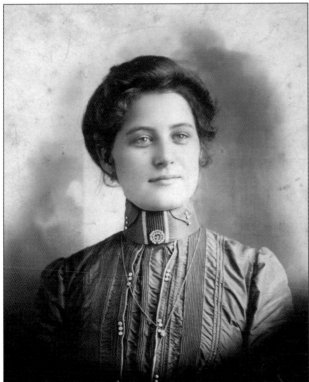

Stella Cholewczynski wears her hair up in a bun for this photograph, but the pleated bodice on her dress is characteristic of the detail common in Victorian-era women's attire. Women such as Cholewczynski during the 19th century had perhaps three dresses: one for work, which she protected with aprons; another for work and shopping; and a third for special occasions. Cholewczynski was born in 1882 and died in 1952. (Courtesy of William Cole.)

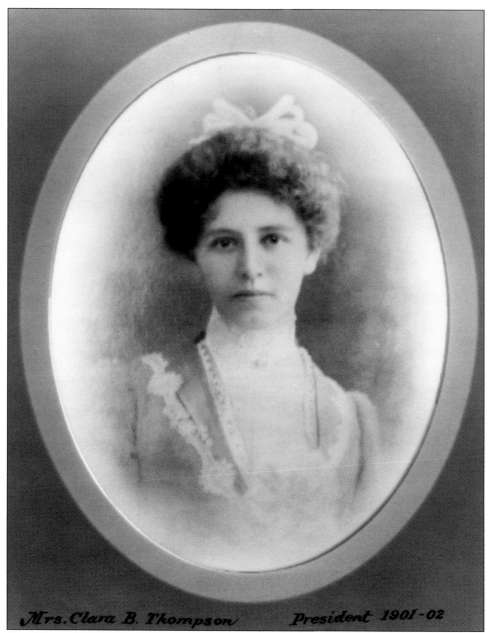

Mrs. Clara B. Thompson *President 1901-02*

A fan of the Gibson Girl look, Clara B. Thompson dresses up her bun with a bow for her Rogers Park Woman's Club portrait of 1901–1902. She is also wearing the high-neck white blouse and the fitted jacket trimmed with lace associated with this early-20th-century trend, which was prompted by idealized illustrations of women by artist Charles Dana Gibson. Thompson's jacket also probably has the voluminous leg-o-mutton sleeves that were popular during this period. Gibson's illustrations became so popular that they appeared on saucers, pillow covers, tablecloths, and other merchandise. The elegant and romantic look of wispy coiffures, bustles, lacy shirtwaists, and hems sweeping the floor lost its appeal after World War I started in 1918, and a more utilitarian wardrobe gained favor. By the time the war was over, hemlines had risen to mid-calf length. (Courtesy of the Rogers Park Historical Society.)

Blouses that were full in the front with a narrow waist and a sash or belt accent were called pigeon front because the puffiness resembled the bird. Nellie E. Lowell dons the trendy top for her portrait as a charter member of the Rogers Park Woman's Club in 1903–1905. The lace could have been made by hand or machine; this traditional handicraft was industrialized. (Courtesy of the Rogers Park Historical Society.)

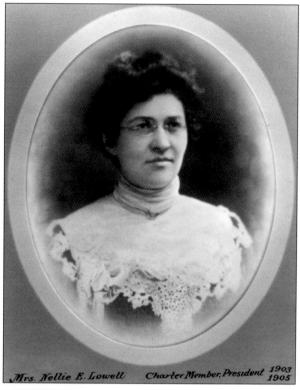

Mrs. Nellie E. Lowell Charter Member, President 1903 1905

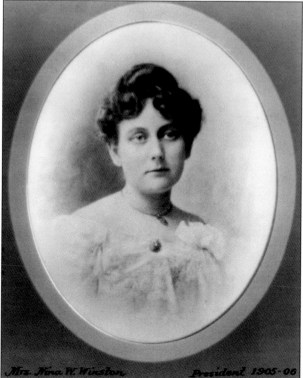

Mrs. Nina W. Winston President 1905-06

Nina W. Winston, president of the Rogers Park Woman's Club in 1905–1906, wears an off-the-shoulder gauzy gown and bares her décolletage for her photograph, shocking for the time. She is displaying some modesty with the flower, and the pendant necklace draws attention away from the daring neckline. The simple circular pin could have been a fad among her friends. (Courtesy of the Rogers Park Historical Society.)

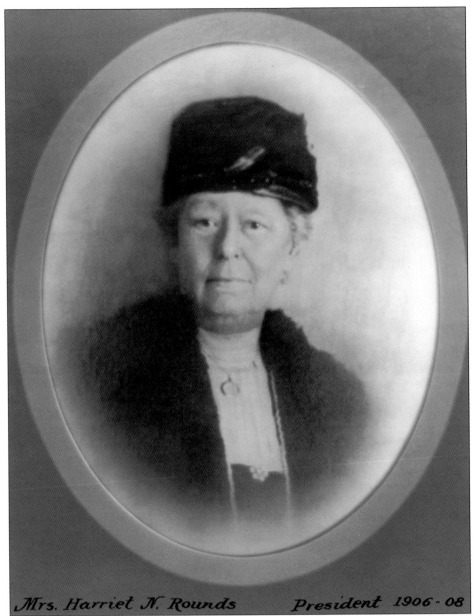

Mrs. Harriet N. Rounds *President 1906 - 08*

While larger picture hats were still popular for dressy events, the toque, such as the one worn here by Harriet N. Rounds, president of the Rogers Park Woman's Club in 1906–1908, was making inroads in the American millinery industry during this period. Rounds's brimless topper appears to be somewhat plain, but women often decorated theirs with hussar plumes and ostrich feathers for additional drama. At one point, milliners adorned hats with stuffed birds, but the Audubon Society and its counterpart in the United Kingdom complained, and that practice eventually ended. Rare bird feathers were banned, and only feathers from certain species could be used. Rounds probably purchased her hat from a local milliner because virtually every Chicago neighborhood had hat designers. Wearing a hat for a formal portrait or photograph was not unusual during the early 20th century; it was common at least through the 1950s. (Courtesy of the Rogers Park Historical Society.)

The art nouveau influence is prevalent in Mrs. Charles Bradley's outfit. The president of the Rogers Park Woman's Club in 1908–1909, Bradley dons a dress with an open neckline that is trimmed with a satin flower-print motif, similar to what was seen on curtains and wallpaper at that time. Her sleeves are simple; by this time the pouffed Gibson Girl was absent. (Courtesy of the Rogers Park Historical Society.)

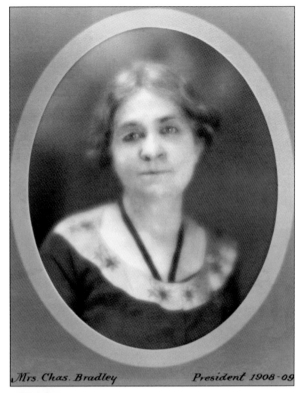

Mrs. Chas. Bradley President 1908-09

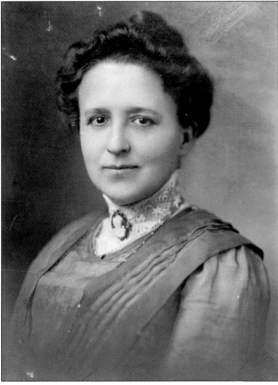

Judge Mary Bartelme was the first female public guardian in Illinois. She was a social reformer and spent much of her career reforming juvenile law and child welfare. In this picture, taken between 1910–1915, she wears a brooch, a trend that was started by Queen Victoria. It became so popular that it was mass produced during the second half of the 19th century. (Courtesy of the Library of Congress, LC-DIG-ggbain-12666.)

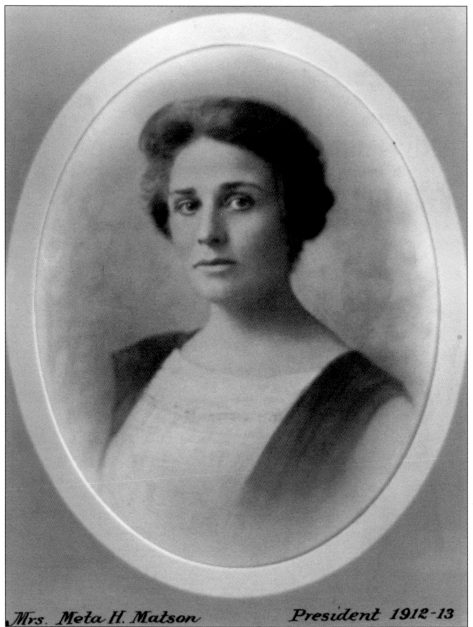

Mrs. Meta H. Matson *President 1912-13*

Meta H. Matson, president of the Rogers Park Woman's Club in 1912–1913, wears a dress ensemble that emphasizes her broad shoulders, a startling contrast to the head-to-toe dark coverage of the Victorian garb from even a decade earlier. Yet the white boatneck blouse and the sleeveless vest were all part of the trend toward lighter, looser clothes that allowed for more freedom of movement for games of tennis and other sports, which were gaining popularity. While the zipper had been invented by Chicagoan Whitcomb L. Judson and patented in 1891, it was refined in the years leading up to World War I. It was initially used in children's and men's trousers and by the 1930s in women's clothes. Parisian designer Elsa Schiaparelli made the zipper, known as a slide fastener, fashionable. It would become common by World War II. (Courtesy of the Rogers Park Historical Society.)

Lena K. Horner, president of the Rogers Park Woman's Club in 1917–1919, was part of a fashion revolution with her daring décolletage on full display: a daring dress with a mesh overlay. Her relaxed look would pave the way for the short hemlines and drop waists of the 1920s. She could have been easily influenced by the silent-film industry, which was in its infancy in Chicago at this time. (Courtesy of the Rogers Park Historical Society.)

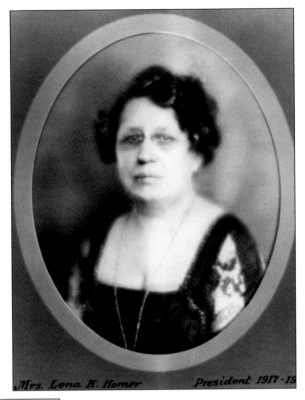

Mrs. Lena K. Horner *President 1917-19*

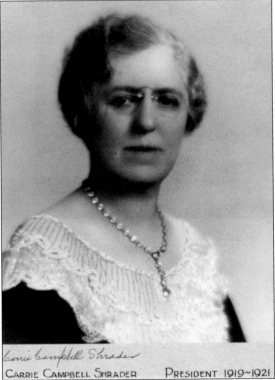

Carrie Campbell Shrader

CARRIE CAMPBELL SHRADER PRESIDENT 1919~1921

Carrie Campbell Shrader, president of the Rogers Park Woman's Club in 1919–1921, wears a pair of pince-nez, which were kept in place by a spring on the bridge of the nose. Women often wore a special brooch that had a line attached to the pince-nez. They could retract the line when the attached glasses were not in use. By the late 1930s, pince-nez were mostly popular with the elderly. (Courtesy of the Rogers Park Historical Society.)

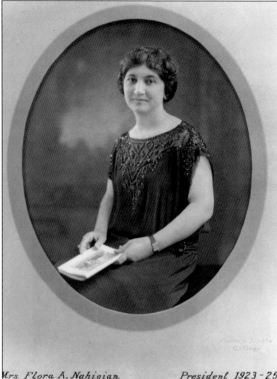

Mrs. Flora A. Nahigian. President 1923-25

Flora A. Nahigian's beaded dress takes center stage in this formal portrait for her post as president of the Rogers Park Woman's Club in 1923–1925. This kind of beading was normally done by hand on silk or crepe de chine and made the dress heavy. Her jewelry is simple with no necklace, but she is wearing a wristwatch. In the past, women wore pendant watches or kept them in a hidden pocket in the seam of their waistband. (Courtesy of the Rogers Park Historical Society.)

This unidentified member of the Rogers Park Woman's Club poses for a 1930 photograph wearing what appears to be a homemade dress trimmed with a bias tape around the square neckline. Since the United States was in the early years of the Great Depression, a dress made at home by hand or machine wouldn't have been uncommon. This woman, wearing a fashionable wavy bob, gussies up her plain garb with a sparkly pendant necklace. (Courtesy of the Rogers Park Historical Society.)

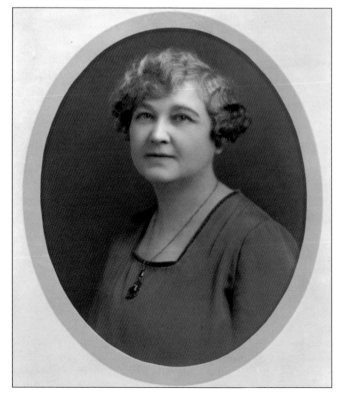

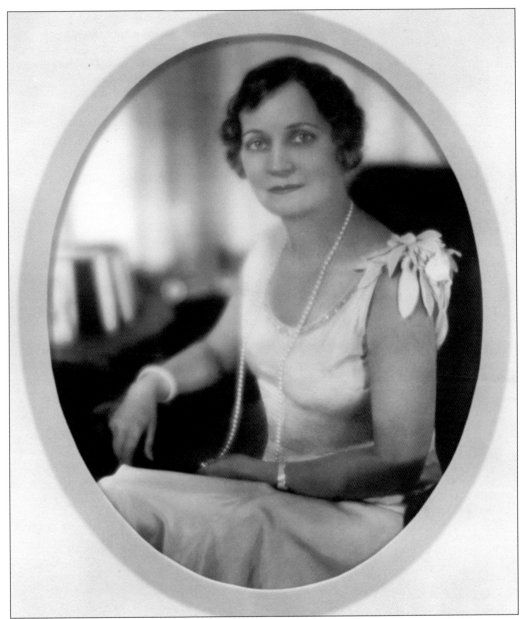

The epitome of Depression-era glamour, this anonymous president of the Rogers Park Woman's Club looks quite stylish in this 1931 shot. She is wearing a strappy white satin or charmeuse dress, likely bias cut, with a matching self-fabric floral embellishment at one shoulder and the subtle beadwork at the neckline. Her look is very sophisticated with her carefully groomed and glossy hair, pencil-thin eyebrows, hint of a suntan, long necklace, bracelet, and wristwatch. Parisian designer Madeleine Vionnet introduced the bias-cut dress, which called for extra yardage, in the 1920s. The fabric was cut on the diagonal so it would cling to the body instead of hanging straight. Glamorous gowns cut on the bias were especially popular during the Depression; the Chicago History Museum has a few Vionnet garments in its collection. These clothes demand extra care because any garment cut on the bias continues to "grow" when it is hung on a hanger for long periods of time. (Courtesy of the Rogers Park Historical Society.)

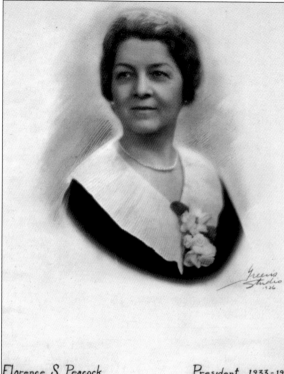

Florence S. Peacock, president of the Rogers Park Woman's Club in 1933, provides a good example of Depression-era chic. Her white pleated collar is easy to remove and launder or attach to another dress. Here she adorns the collar with the same kind of flowers found on hats during that era. Her jewelry is equally thrifty with just a simple pearl necklace and matching earrings. (Courtesy of the Rogers Park Historical Society.)

Florence S. Peacock President 1933-19

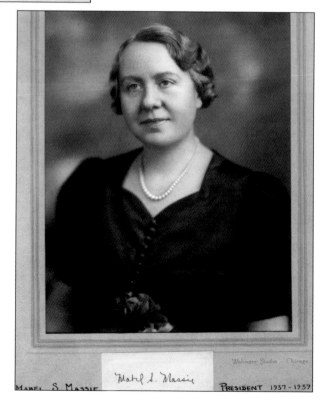

Mabel S. Massie, president of the Rogers Park Woman's Club in 1937–1939, wears a dress with a sweetheart neckline, which was particularly popular with young women through World War II. With self-fabric buttons down the bodice front, her dark dress has a special occasion look about it, especially the silk flower at the waist. It could have easily been worn to a dance hall. (Courtesy of the Rogers Park Historical Society.)

Mabel S. Massie President 1937-1939

52

Sewing books during the 1930s and 1940s often had entire sections on what kind of dress silhouettes, sleeves, and necklines were most youthful looking. Gertrude W. Dewire, president of the Rogers Park Woman's Club, wears a dress with three-quarter-length sleeves in 1939. This type of sleeve looked good with long gloves, either in a washable leather or a sueded cotton at Sears, Roebuck and Company and other stores. (Courtesy of the Rogers Park Historical Society.)

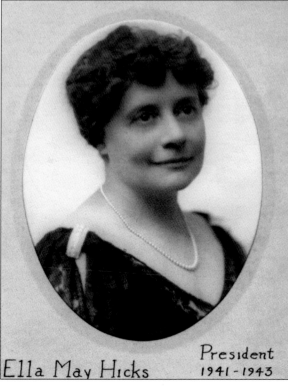

Ella May Hicks

President 1941-1943

Ella May Hicks, president of the Rogers Park Woman's Club in 1941–1943, looks like a throwback from Victorian times with her lacy black dress, which is simply embellished with a pair of rhinestone-and-gold clips, a common accessory on dresses during the Depression and World War II. The clips usually had a set of "teeth" on the back so they could adhere firmly to the dress fabric. (Courtesy of the Rogers Park Historical Society.)

53

MARJORIE E. MUELLER PRESIDENT 1945-1947

Marjorie Eanis Mueller.

Marjorie E. Mueller, president of the Rogers Park Woman's Club in 1945–1947, poses for a photograph at Greens Studio wearing a dress with a distinctive embroidered motif on the bodice. These kinds of ornamentation were particularly common during World War II when fabric rations led women and manufacturers to add dress details that hinted at luxury. Pattern companies such as Simplicity, Vogart, Aunt Martha's, and others sold iron-on transfer patterns, which allowed home sewers to iron on faint blue outlines to fabric that they would cover with embroidery. Large-motif embroidery continued to be popular through the 1950s, when sewers would embellish hand-stitched initials on cardigan sweaters with rhinestones and beading. The best-known example of this type of embellished cardigan was the one worn by actor Penny Marshall in the television show *Laverne & Shirley*. It had an oversized *L* on the left shoulder. (Courtesy of the Rogers Park Historical Society.)

Four

HATS OFF
TO THE WINDY CITY

A sisal hat embellished with a huge taffeta bow is the centerpiece of this 1911 photograph of Chicagoan and opera soprano Mary Garden. While still large, Garden's topper is considerably smaller than the massive ones worn by her counterparts in the late 1800s. The masculine touch of buttons on her jacket cuffs, and even Garden's confident pose, presage the women's rights movement. (Courtesy of the Library of Congress, LC-USZ62-112002.)

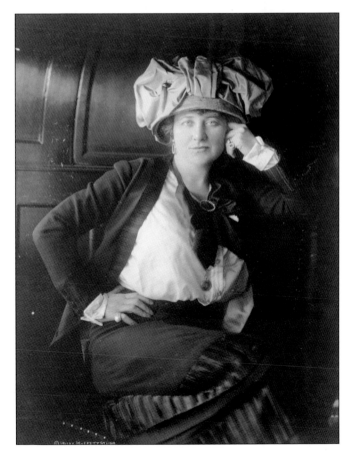

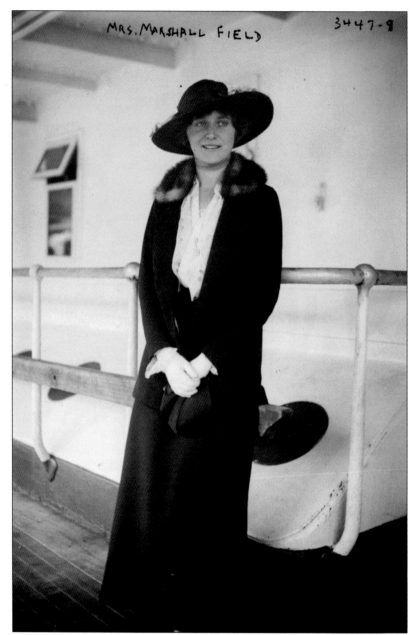

Mrs. Marshall Field, in an undated photograph, is the picture of decorum in her traveling outfit. She is wearing a dark straw hat embellished with a fine netting over her wavy bob, a fur-trimmed wool coat over her lacy white shirtwaist, and her white kidskin gloves with hands tightly clasped over a small handbag. Field appears to be standing on a ship platform. Any long-distance travel on a ship during the early 20th century required wardrobes, steamer trunks, hat boxes, and other pieces of luggage. Marshall Field was the founder of the department store of the same name; the main store, a local landmark, was on State Street in Chicago's downtown. Marshall Field actually made trunks before he became known for his store; he was in the luggage business from the late 1800s through the 1940s. The Chicago History Museum owns several pairs of Mrs. Field's shoes, nearly in mint condition. (Courtesy of the Library of Congress, LC-DIG-ggbain-18882.)

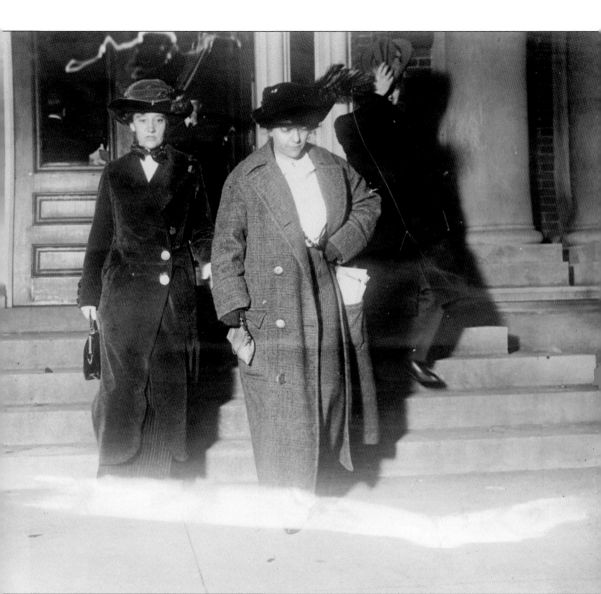

Mrs. Medill McCormick (left) and Alice Longworth Roosevelt (right) are photographed here in 1912 leaving Mercy Hospital following a visit to Roosevelt's father, former president Teddy Roosevelt, who was hospitalized after an assassination attempt. Both are wearing the broad-brimmed, high-crown cartwheel hats typical of the early teens. McCormick has chosen what appears to be a dark velvet double-breasted coat; Roosevelt dons an equally lengthy plaid wool coat with large pockets, one of which is stuffed with documents. They both carry small handbags and wear skintight gloves. The quick-witted Roosevelt was a favorite with newspapers of the period; reporters were eager to note what she wore and where she went. Her favorite blue-gray color, which matched her eyes, became known as "Alice Blue" in the fashion and home-decorating circles. Newborns also were named after her. While McCormick did not receive nearly as much attention, she later picketed with garment workers in 1915. (Courtesy of the Library of Congress, LC-DIG-ggbain-10922.)

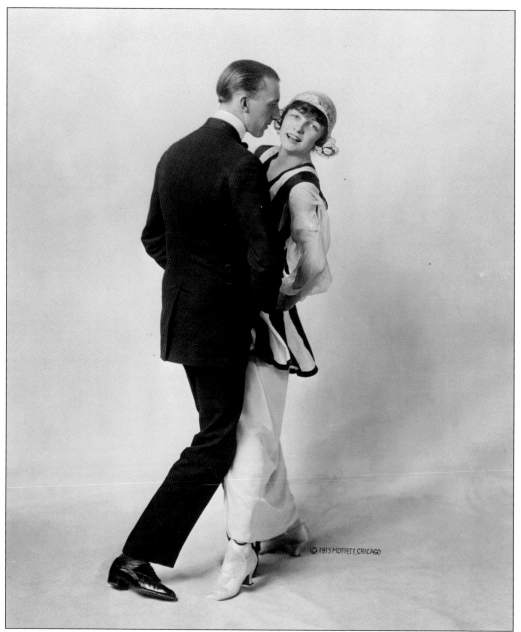

Famed dancers Vernon and Irene Castle made a career of traveling nationwide, promoting the hands-free Tango, which they are demonstrating in this 1913 photograph. Irene is wearing a lacy hat, and it was likely she dressed this way while performing with her husband. It wasn't uncommon for women to wear hats while out on the dance floor. It was seen as proper, even graceful. However, a man was always expected to take off his hat when entering a house or building. Irene was a major trendsetter during this period. She bobbed her hair about 10 years before the look became common. Her skirts were also shorter than usual, however, that didn't stop women from copying her look. While Irene's wardrobe was supplied by a couturier, she designed many of the clothes herself. The couple traveled to major cities, including Chicago, before Vernon died in an airplane crash in 1918. (Courtesy of the Library of Congress, LC-USZ62-120307.)

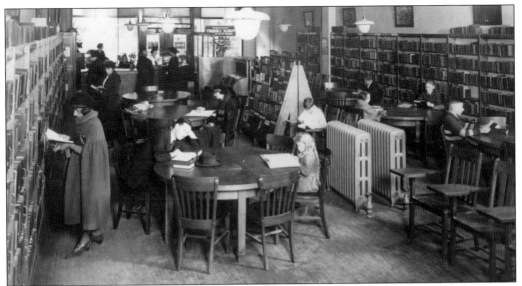

Rules were rules during 1915 when the Rogers Park Library was established by the Rogers Park Woman's Club. Esteemed architect Marion Mahoney Griffin (left) could wear her hat inside the new building, but boys, such as the one slouching on the table, had to take their hats off. This unwritten edict was also true for public buildings such as churches, courthouses, and new-fangled elevators. (Courtesy of the Rogers Park Historical Society.)

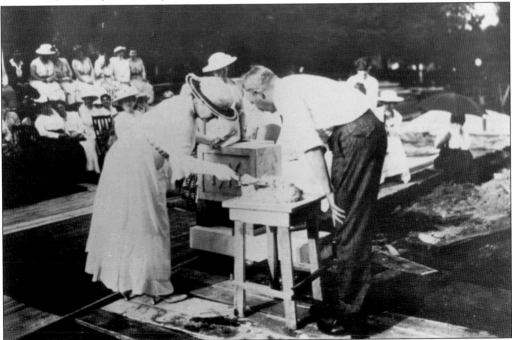

A ground-breaking for the Rogers Park Woman's Club at 7077 North Ashland Avenue was a significant event in June 1916, and it warranted that all women don hats, even if rain seemingly dampened the occasion. White hats were au courant for spring and summer during the early 20th century. The women's group operated at this building for 70 years before it relocated. (Courtesy of the Rogers Park Historical Society.)

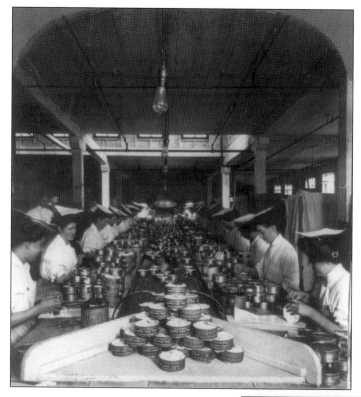

Wearing the flattest of worker caps on top of their coiffures, these women sit side by side in 1919 as they label cans of the "Veribest" in Armour's packing plant, a central Chicago facility where various meat products were packaged through 1959 (when the company stopped slaughtering). In 1970, the company was bought by Greyhound Corporation and relocated to Arizona. (Courtesy of the Library of Congress, LC-USZ62-97322.)

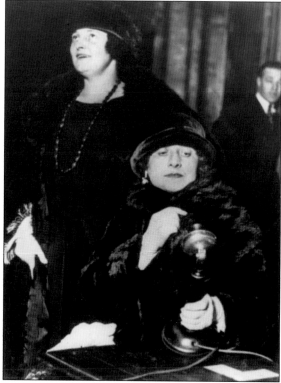

Opera singers Mary Garden (left) and Edith Mason wear fur coats and hats in this 1921 photograph; through the 1940s, radio performers often wore hats and outer garments, even gloves, while recording, partly because the studios were kept chilly to counter the hot lights that illuminated the performers for the live audience. The cloche, along with the flapper dress, became a signature look of the 1920s. (Courtesy of the Library of Congress, LC-USZ62-73232.)

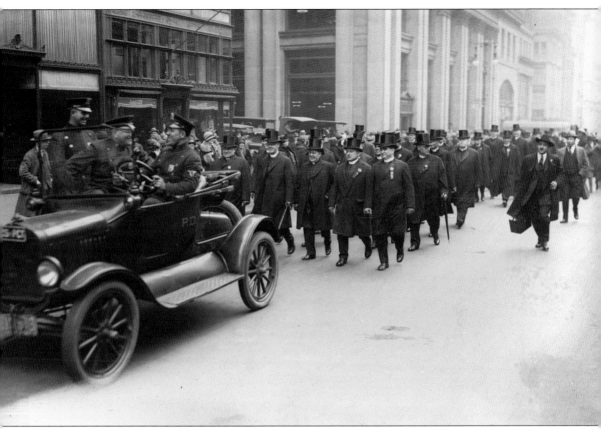

Wearing top hats, a group of Chicago Roman Catholic men calls on Cardinal Hayes (1867–1924), who presided over the Archdiocese of New York, in this undated photograph that appears to have been taken sometime in the 1920s judging from a passerby's cloche and flapper-style coat. At the height of their popularity, top hats became associated with the elite, and thus consequently the object of satire in newspapers. Only the rich could afford a top hat since it was handmade by a skilled milliner. Abraham Lincoln was well known for his top hat; he reportedly kept important letters inside it. Later middle-class men rebelled against the elites by wearing bowlers and fedoras, which could be mass produced unlike top hats. With few young people keen on mastering the trade of crafting top hats, interest in it waned. Now top hats are rarely worn except for musicals, magicians, and the occasional bridegroom. (Courtesy of the Library of Congress, LC-DIG-ggbain-37107.)

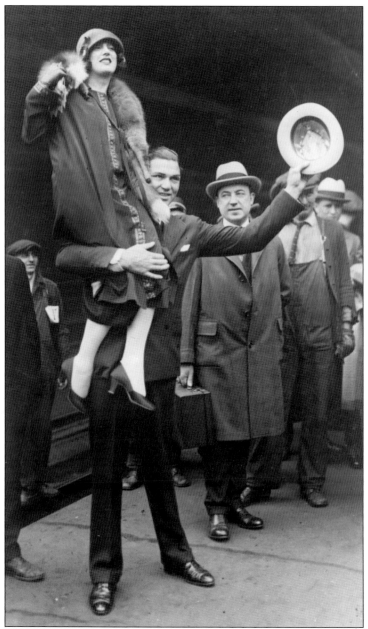

Celebrities such as boxer Jack Dempsey and his wife, Estelle Taylor, were often greeted by photographers and reporters when they arrived in town or switched to another train on their way either west or east. Taylor also has what appears to be a martin fur pelt around her shoulders in this 1925 photograph, the same year that the couple married. Pelts such as these were often worn with a clip so the fur would not slide off the shoulders. A silent-film actor, Taylor had a collection of hats. She was most known for her role in *Monte Cristo* and Cecile DeMille's *Ten Commandments*. She also appeared in the first feature-length film (*New York*) with sound effects and a musical soundtrack in 1927. She was awarded a star on the Hollywood Walk of Fame for her contributions to the motion-picture industry. She died in 1958. (Courtesy of the Library of Congress, LC-USZ62-132002.)

Matching mother and daughter ensembles were not uncommon in 1927 when this photograph was taken of an unidentified Rogers Park mother and her children. Cloches for adults and children were embellished with cording, feathers, fur buttons, ribbons, and other textiles, making them unique fashion statements. Sometimes these flourishes were removable, allowing the wearer to attach another ribbon to update the hat. (Courtesy of the Rogers Park Historical Society.)

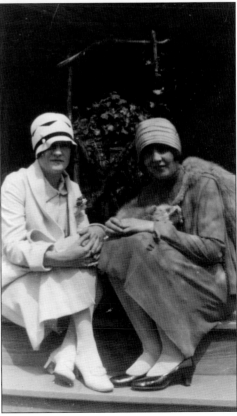

Chicagoans, men and women, never traveled far without their fur coats and accessories. The unidentified Logan Square resident (right) complements her outfit with a martin fur pelt, which is likely lined with matching satin, over a plaid dress in 1929. Even on the West Coast, where this picture was taken in the late 1920s, women wore furs during cool evenings or cold days. (Courtesy of Tom O'Keefe.)

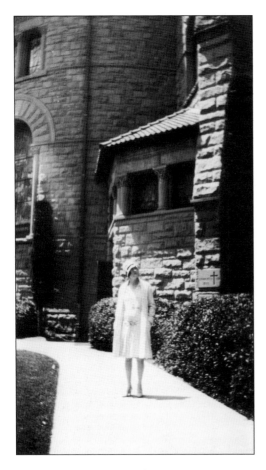

Long-distance trips became more popular and frequent as more reliable and faster automobiles were manufactured. A shawl-collar duster, such as the one on this unidentified Logan Square resident on vacation in California in the late 1920s, was suitable for travel. It covered her up and protected her from road dust. It was an unwritten rule to match hats with outer garments, usually using the same fabric. The woman's soft-structure, close-fitting cloche was possibly made from wool felt, but hats during the 1920s were also made from straw, cotton, linen, silk shantung, and other natural fibers. There were also patterns available for knitted cloches. (Courtesy of Tom O'Keefe.)

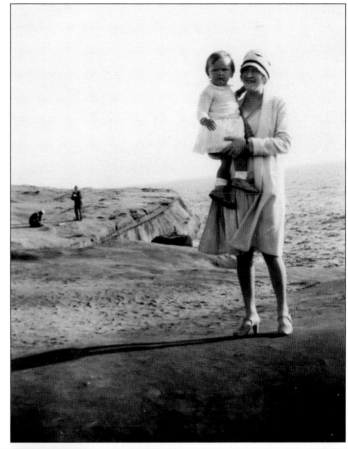

Wearing a hat, dress, and shoes on the beach, such as what this unidentified Logan Square resident is seen here doing during a late-1920s vacation to California, would have been perfectly acceptable during the era; full-coverage protection from the damaging effects of the sun was still ideal. Tanning would not catch on with most Americans until the 1930s and 1940s, when movie stars and magazines made it socially acceptable. Dressing up to visit tourist destinations, as this resident did, was common. (Courtesy of Tom O'Keefe.)

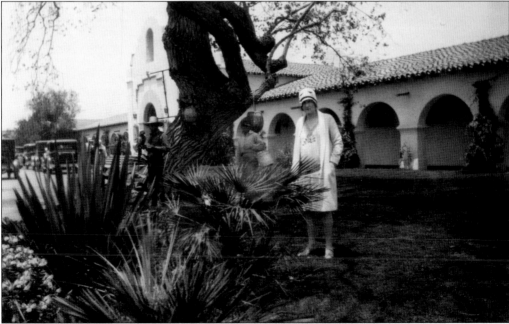

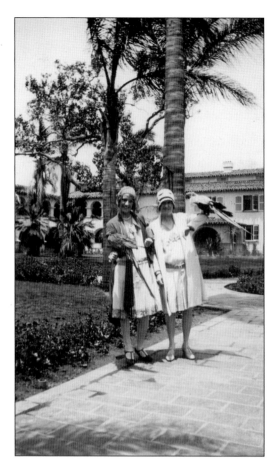

Cloches were not all alike during the late 1920s. Some draped down the side of the head for an interesting effect; others had feathers, which were readily available from various international sources before the bans on feathers from endangered bird species, or buttons—the larger, the better since they added more drama. Besides, most women had button collections, and it was easy enough to find an odd button that could be used to freshen up a cloche, which was usually worn over short hair and never long locks. By the end of the decade, there was more ready-to-wear footwear. Salvatore Ferragamo and Perugia had a line of custom shoes in the 1920s. Pumps with art deco motifs on the vamp, such as those worn by the unidentified Logan Square resident (below left), were a trend too. (Courtesy of Tom O'Keefe.)

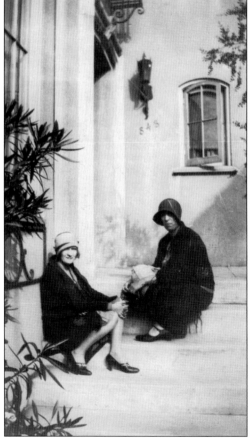

Here Chicago sisters Esther (left) and Irene Giese are the epitome of early-1930s style. Windowpane plaid was a popular print during this time, not just on coats like Esther's but also on aprons, skirts, and blouses. Esther's fitted black coat with a grand white-and-tan fur capelet is typical of the time. Women's wool coats were often trimmed with fur, which could be removed for cleaning and storage. (Courtesy of Lynn Furge.)

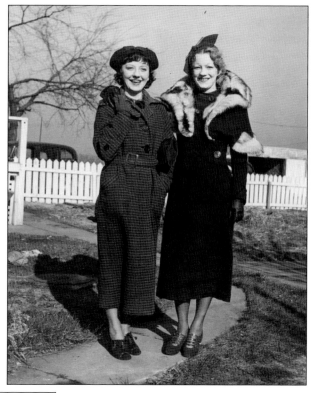

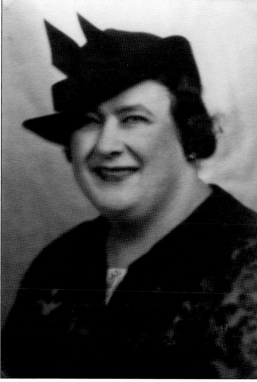

Blandene Allerton, a member of the North Town Woman's Club in Rogers Park, is the picture of sunniness in the middle of the Great Depression in 1935. She is wearing a lively felt hat with a brim that appears to curl upward, an effect likely achieved by sewing millinery wiring inside the brim. The matching embellishment on top of the crown is also probably wired to make it stand upward. (Courtesy of the Rogers Park Historical Society.)

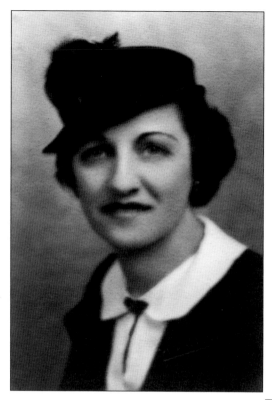

Wearing a hat with an Austrian feel adds an outdoorsy element to this unidentified North Town Woman's Club member's hat, which is worn at left for a 1935 photograph. The pom-pom was an inexpensive detail, popular during the Depression when Americans were short on cash, but long on creativity. A pom-pom also adorns the playful, slouchy hat on fellow member Lucy Lyman's hat. Pom-poms could be made from yarn leftover from knitting projects. In addition to hats, pom-poms often adorned women's jackets and blouses. These trims add a jauntiness to what is otherwise a carefully groomed, serious look. It was antidote to the times, when so many Americans were out of work. (Courtesy of the Rogers Park Historical Society.)

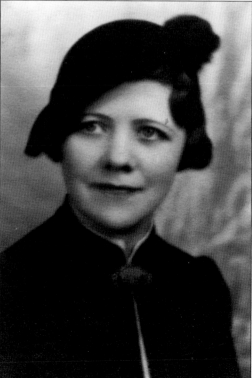

Tyrolean hats, which take their name from the alpine region in Austria and Bavaria—Tyrol—were a signature look of the Depression. North Town Woman's Club member Ida Blackman is wearing one for a 1935 photograph. The creased fold in the middle of the crown was achieved by shaping wet felt on a dome-shaped woodblock. When the felt was dry, it was sewn to a separate brim. (Courtesy of the Rogers Park Historical Society.)

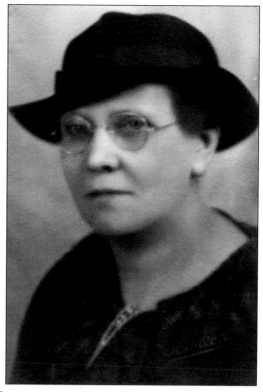

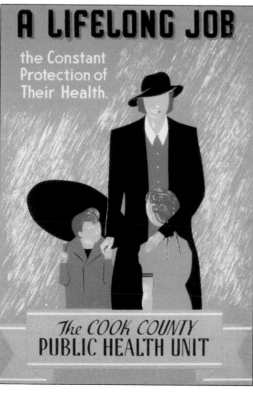

Created as part of the Illinois WPA project between 1936 and 1941, this Cook County Public Health poster demonstrates the importance of matching accessories. Coordinating coats, gloves, and even handbags were encouraged through the 1950s. It was, in part, a marketing ploy for department stores to sell more accessories; a planned outfit with identical frills was the mark of a well-dressed woman. (Courtesy of the Library of Congress, LC-USZC2-5237.)

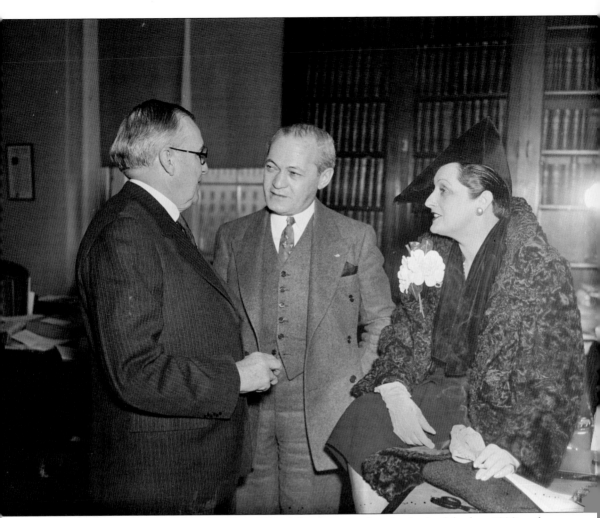

Chicago opera singer Fern Audro's faux Persian lamb coat, a favorite look of the late 1930s, takes center stage in this photograph. Faux Persian lamb coats were made with oil-based polymers in 1929. However, faux fur through the 1930s was dyed gray or tan until the 1940s and 1950s, when acrylic monomers and polymers allowed more complex dying and tufting from the spinnerettes. These coats were usually only available in black and were generally lined with rayon. Faux furs were popular with thrifty Chicagoans during the Great Depression. Audro is also wearing a dramatic pointy felt hat for her visit in Washington, D.C., with representatives John H. Kerr (left) and Samuel Dickstein (center). It was considered proper etiquette for women to keep their hats when calling on officials. Her angular black felt hat has a distinct military influence, which was popular during World War II. (Courtesy of the Library of Congress, LC-DIG-hec-22296.)

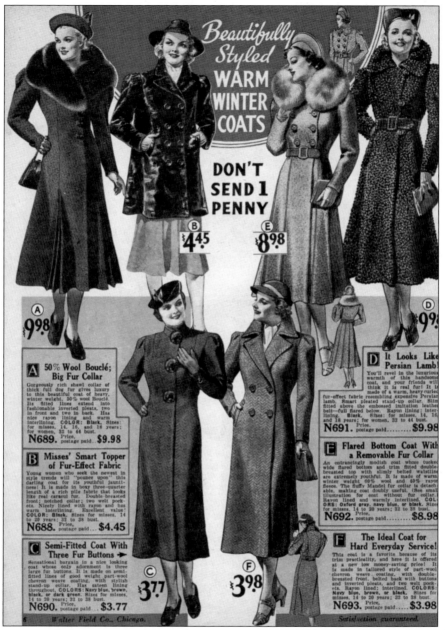

The princess-style coat was the rage with young women in 1938 and looked perfect with the feminine skirts and dresses that were in style during that period. The now-defunct Walter Field Company had variations available, ranging from one with an oversized fur collar to one made with faux Persian lamb. For those who could not afford a coat, there was the less costly three-quarter, faux-fur "topper." During the Depression, women learned how to replace the linings of their coats to save money or to sew their own coats using instructions from Vogue, Simplicity, and Butterick pattern companies. During World War II, women would take old coats and cut them apart to make suits, skirts, and vests. The leftover wool scraps were even useful; they could be cut into thin strips for rug-hooking projects, such as those produced by Pearl K. McGown. (Author's collection.)

Everything from Art Carlson's doubled-breasted jacket and pants to Dorothy Lauter's head-to-toe ensemble could be bought in 1938 at local department stores such as Montgomery Ward and Sears, Roebuck and Company. Chicagoans like Carlson and Lauter had easy access to stores downtown or in the neighborhood; rural residents had to order their garments using catalogs, which were popular for decades. Even netting, used to embellish hats, was readily available by the yard through department stores and catalogs. Since the fragile fabric tore easily, it was ideal to keep a stash to quickly replace a torn veil. The veil was usually worn over the front of the hat or loosely tacked to the brim. Chenille pipe cleaners cut into small sections could be used to make plain netting fancier for a cocktail hat. (Courtesy of Kay Kusiak.)

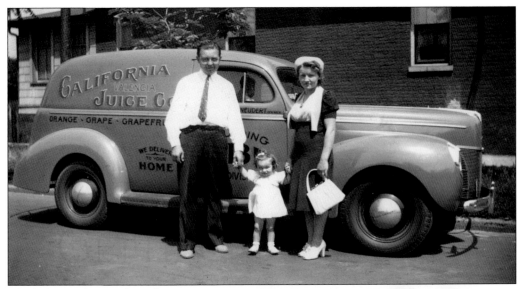

The bolero jacket, such as the one Chicagoan Rose Neudert is wearing in this early-1940s photograph, was a popular look in the 1930s and 1940s. During the Depression, the short-sleeve, short jacket was a thrifty way to dress up an outfit. It could be made from a few skeins of yarn or less than a yard of fabric. These jackets were also the perfect complement for dresses with fitted midriffs such as the one Neudert is wearing. A fan of hats, Neudert dons a black velvet pillbox decorated with matching netting, also called Russian veiling, in another photograph from the same period. (Courtesy of Lorraine Klatt.)

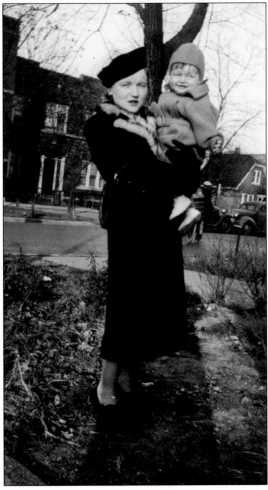

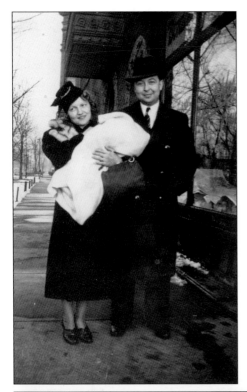

Rose Neudert is wearing a black toque embellished with faux feathers, a popular style in the early years of World War II, for the christening of her daughter Lorraine, who was born in 1939. The toque probably had a petersham, a ribbon with picot edging, stitched inside the brim to keep sweat and makeup at bay. The petersham could be easily removed and replaced. Richard Neudert's fedora also has a similar band inside. (Courtesy of Lorraine Klatt.)

Most hats were off for this 1942 shot at the Club DeLisa, where African Americans and whites mingled on the dance floor for music played by Theodore Dudley "Red" Saunders and his band. Curls and pompadour-influenced hairdos were the rage of the day, as were dresses with shoulder pads, such as the one worn by the woman in the center. Most women brought their small handbags onto the dance floor for foxtrot and other slow numbers. (Courtesy of the Library of Congress, LC-USW3-001533-D.)

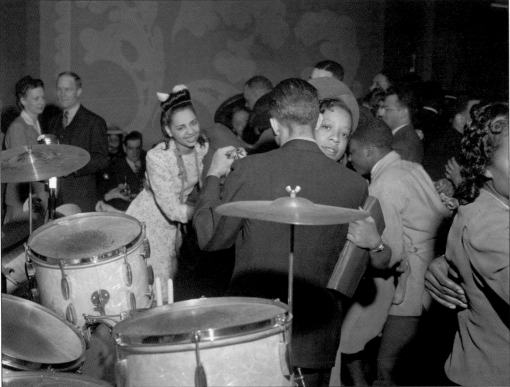

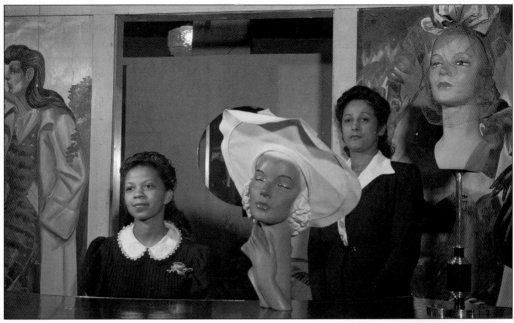

Millinery shops were the lifeblood for Chicago neighborhoods with some hat designers becoming household names. On Chicago's North Side, Benjamin Greenfield, a lifelong milliner, made custom designs for celebrities. Clerk Minnie Coleman (left) and Selma Barbour (right), manager of the Cecilian Specialty Hat Shop at 454 East Forty-Seventh Street, were the South Side's success story. Here they pose with the hats for Easter 1942. (Courtesy of the Library of Congress, LC-USW38- 001470-D.)

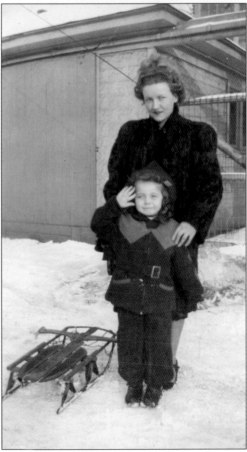

Independent women's and children's clothing stores abounded in Chicago neighborhoods in 1942–1943. Rose Neudert worked at one near the Chicago and Ashland Avenues intersection; she commuted there on the streetcar from her Humbolt Park home. An expert sewer, she altered customers' attire. She could have purchased her daughter Lorraine's two-tone belted playsuit from a local shop, saving her from a commute downtown on the Chicago Avenue streetcar. (Courtesy of Lorraine Klatt.)

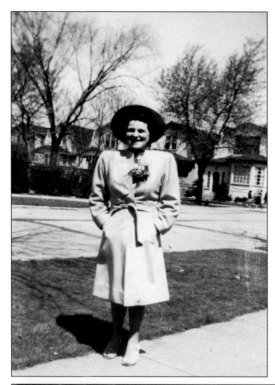

With her hands tucked in her pockets and standing in front of her Gladstone Park home, Janet Ross is dressed for Easter Sunday in 1944. She is wearing a collarless white coat with a wide-brimmed straw hat, a look she finished off with a corsage on her lapel. The shoulder pads, a popular touch on outerwear, make her shoulders appear broader. (Courtesy of Kay Kusiak.)

All types of hats are on display for a photograph celebrating Chicago Public Library Week in 1945 at the North Town branch in Rogers Park. The mid-1940s are considered the height of design in the history of millinery. Designers became extremely creative with the wartime ration on fabric, leading to unusual trimmings such as the fabric-wrapped hat pillbox (woman standing on the left). (Courtesy of the Rogers Park Historical Society.)

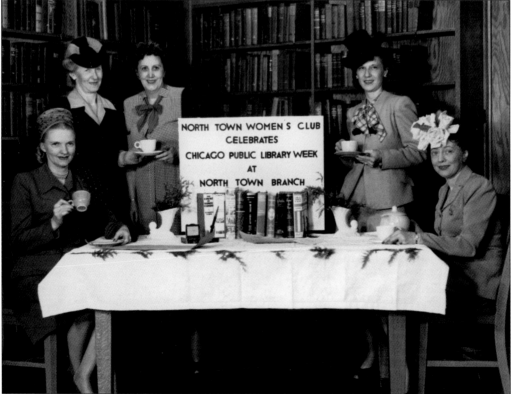

Five

MAKE ME PRETTY ONE DAY

Flora M. Foote, founder and president of the Rogers Park Woman's Club in 1891–1893, wears her dark hair swept up with a fringe of curls in the front, a style that remained popular through the late 1950s and early 1960s until long, straight hair became commonplace. Even today, the fringe of curly bangs is often associated with the 1939 movie *Gone with the Wind*, which is based on the novel by Margaret Mitchell. (Courtesy of the Rogers Park Historical Society.)

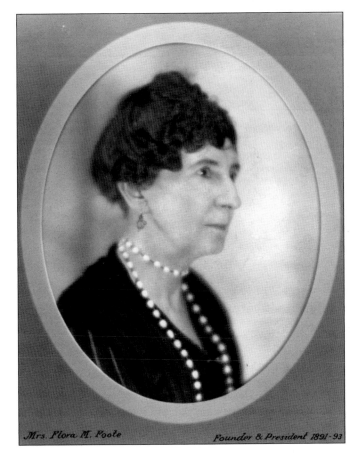

Mrs. Flora M. Foote Founder & President 1891-93

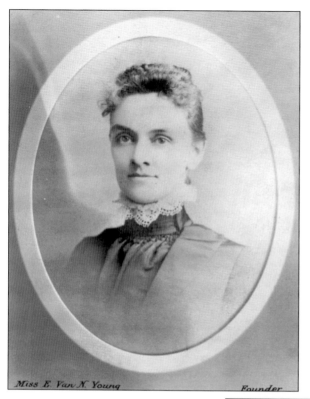

Miss E. Van N. Young Founder

Scalloped-edge white lace often softened the edges of the black high-collar dresses, such as the one E. Van N. Young is wearing in the late 1800s. The lace also served a practical purpose, for it kept the dress clean and could be easily removed for washing. Young was a founder of the Rogers Park Woman's Club in 1891. Ada R. E. Clark, a charter member of the group in 1891, is wearing the popular bib blouse. With its high collar and bodice embellished with a chevron of lace insets, it was suitable for everyday wear. Her hair is piled high on her head with a fringe of light bangs, a popular look with matrons of that period. (Courtesy of the Rogers Park Historical Society.)

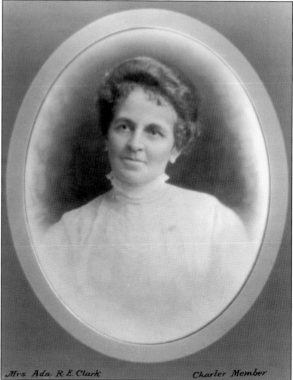

Mrs. Ada R. E. Clark Charter Member

Clara L. Doland peers off to the side in this photograph documenting her work as a charter member of the Rogers Park Woman's Club in 1891. She is wearing her hair pulled back with curls framing her face—possibly done with a hot curling iron, which was invented in 1890. It is also possible she made her curls using strips of old rags tied and worn until her damp hair dried, usually overnight. Another charter member of the group during the same year, Susan G. Sullivan, has puffy bangs, a look that would be revived during the early 1940s. She also is wearing a classic day dress with a dark, high collar and leg-of-mutton sleeves, which are full at the armhole and taper to the wrist. These sleeves alone required a yard or two of fabric. (Courtesy of the Rogers Park Historical Society.)

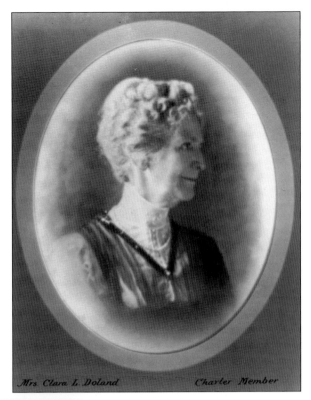

Mrs. Clara L. Doland *Charter Member*

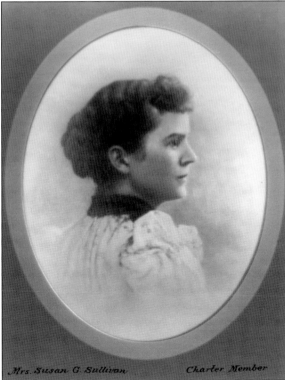

Mrs. Susan G. Sullivan *Charter Member*

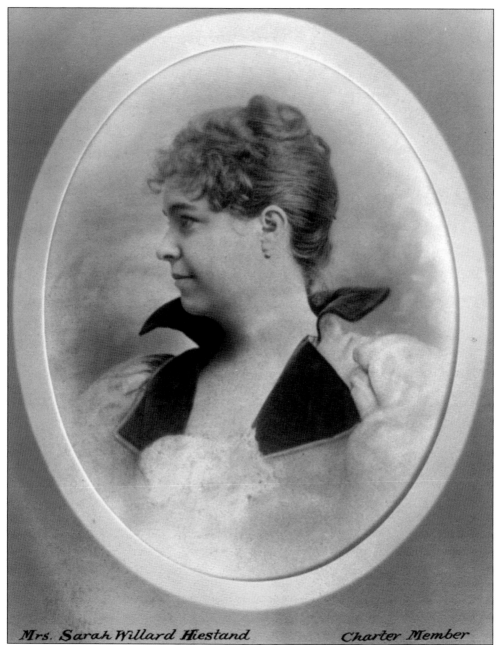

Mrs. Sarah Willard Hiestand *Charter Member*

Sarah Willard Hiestand appears dramatic in this 1891 photograph recording her work as a charter member of the Rogers Park Woman's Club in 1891. She is commanding attention in her black-and-white dress with its dramatic velvet lapel and collar, which was vaguely reminiscent of the ornate tunics that men wore during the Medieval era. It could have been wired with horsehair (from the mane of a horse) or organza to make it stand erect, which were common sewing materials used to wire women's hats and undergarments. In addition, it was used for upholstery stuffing in the 1800s. It was also a critical component in creating the bouffant coiffures associated with the Gibson Girl look; during the 1700s, it was used in wigs. Horsehair intended for sewing and millinery purposes today is generally a synthetic material. (Courtesy of the Rogers Park Historical Society.)

Agnes R. W. Brigham, charter member and president of the Rogers Park Woman's Club in 1894–1898, has parted her hair in the middle, a look that was popular with men and women during the Victorian era. For men, the look disappeared by the 1930s and has never really experienced a revival, although the center part, long straight hair, and no bangs was one of the trademarks of the 1960s hippie movement. Georgina N. Wild, charter member and president in 1893–1894, has styled her hair in a center part, a spartan look that was only softened by her wavy hair. She is wearing what appears to be a dark, heavy cape with bound buttonholes, brass buttons, and a fold-over collar finished with a frill of lace and a cord necklace. Her earrings are barely noticeable. (Courtesy of the Rogers Park Historical Society.)

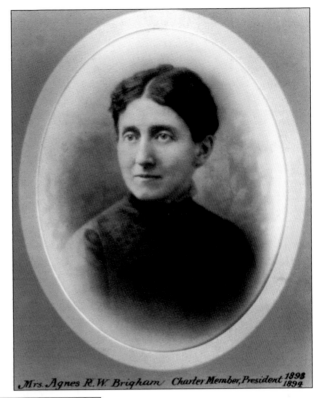

Mrs. Agnes R. W. Brigham Charter Member, President 1898 1894

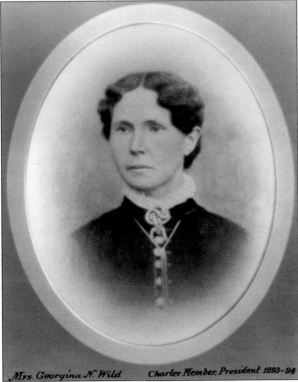

Mrs. Georgina N. Wild Charter Member, President 1893-94

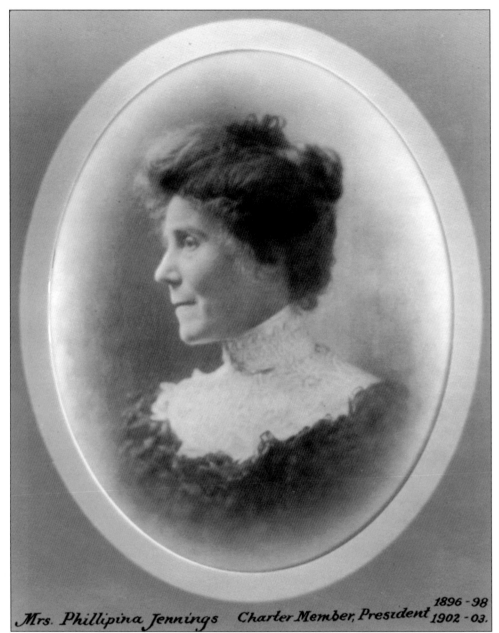

Mrs. Phillipina Jennings *Charter Member, President* 1896-98 1902-03.

A charter member and president of the Rogers Park Woman's Club in 1896–1898 and 1902–1903, Phillipina Jennings wears her hair pulled back into a bun. She is also wearing a granny waist, a fitted bodice with a lace insert in the front, and larger ruffles around a low neckline. The granny waist was so named for the type of blouse that grandmothers liked to wear during the 1890s. The shirtwaist, whether it was for matrons or young mothers, was a central piece in a woman's wardrobe during this period. *Modern Priscilla* sold perforated patterns for these blouses for those who could afford it. The magazine also sold three yards of lawn or linen with the waist stamped on it. Matching belts and hats were extra. The shirtwaist became a symbol for workers' rights—there was a New York shirtwaist strike in 1909 and the famous Triangle Shirtwaist Factory Fire in 1911. (Courtesy of the Rogers Park Historical Society.)

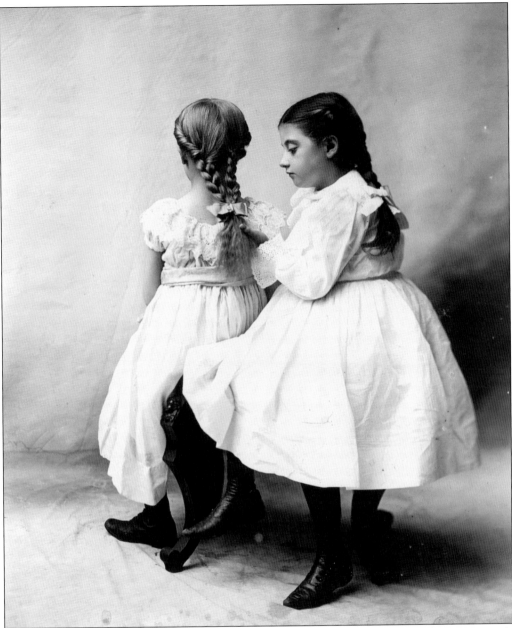

Braided hair seemingly never went out of style if this 1900 Chicago photograph of two young girls with long plaits of hair is any indication. Braids were also popular with women since many had long hair. It was common to wear a pompadour in front with a long, thick braid in front; another popular look was two braids on top of the head or to tack them together at the nape of the neck. False hairpieces, called frizettes, and small wave pieces also allowed women during this period to add more hair to their elaborate coiffures. During the Victorian era, it was popular to snip hair from a loved one and transform it into rings and bracelets or insert it into a locket. Fancier rings of hair were incorporated into framed pieces of wall art in a hobby that was popular during the Victorian era. This hair art can still be found in antique stores. (Courtesy of the Library of Congress, LC-USZ62-107155.)

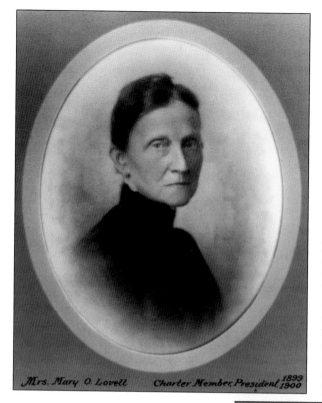

Mrs. Mary O. Lovell Charter Member, President 1899–1900

Mary O. Lovell, a charter member and president of the Rogers Park Woman's Club in 1899–1900, is wearing a plain black high-collar dress with a black-on-black print and a hint of lace at the neck; it was the kind of gown that could easily be worn to one's wedding or a funeral. This dress was also popular with older women, who were more accustomed to subdued attire. Anna W. Graf, charter member and president of the group in 1909–1911, is wearing her hair lightly fluffed around her round face, perhaps prompted by magazines such as the *Delineator*, which prescribed advice on hairstyles. Graf also dons a dress that is starkly different and simpler than what was worn even a decade earlier. For a day dress, the open neckline is somewhat daring; in the past, something that revealing would have been worn for a special evening event. (Courtesy of the Rogers Park Historical Society.)

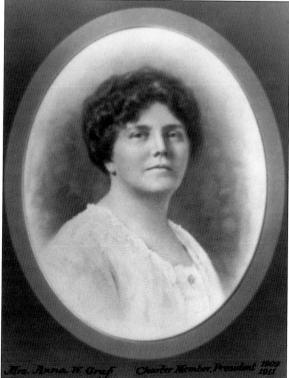

Mrs. Anna W. Graf Charter Member, President 1909–1911

A practical coiffure was ideal for Harriet C. B. Alexander, M.D., president of the Rogers Park Woman's Club in 1894–1895. Female physicians were rare in the late 1800s; Dr. Alexander was an anomaly, but she could have trained at area medical colleges and universities. An unidentified Rogers Park Woman's Club president, in 1895, wears her hair rolled into a bun on top of her head and dons a high-collar black blouse with full sleeves that are ruched at the sleeve head. Ruching, which is essentially pleating a strip of fabric so that both sides are ruffled, was a popular embellishment during the Victorian era and could often be found on the bodice and sleeves of dresses. (Courtesy of the Rogers Park Historical Society.)

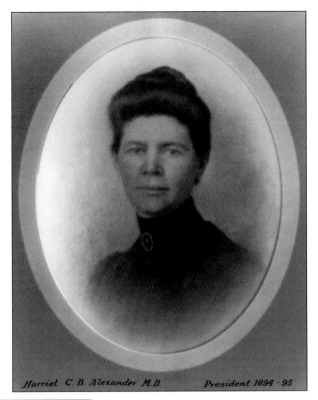

Harriet C. B. Alexander M.D. President 1894 · 95

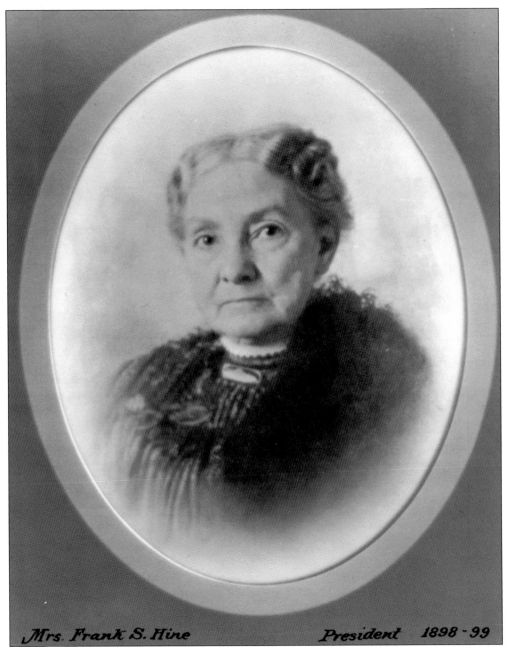

Mrs. Frank S. Hine *President 1898 - 99*

Mrs. Frank S. Hine, president of the Rogers Park Woman's Club in 1898–1899, has parted her hair in the middle with a probable chignon at the nape of her neck, a look that was popular with older women through the middle of the 20th century. She also is wearing a black dress with a high neck and what appears to be a Mongolian lamb fur capelet over one shoulder. The dress could have been made from crape, a silk gauze used for mourning attire; other black fabrics popular for mourning attire included plain bombazine, paramatta, merino wool, and cashmere, depending on the widow's income. However, not all black dresses from the Victorian era were intended for mourning. A dress had to be more than black for it to be a genuine mourning outfit; it also had to meet certain etiquette of the period. (Courtesy of the Rogers Park Historical Society.)

An early adopter of the Gibson Girl look, Jeanette D. Welch, president of the Rogers Park Woman's Club in 1900–1901, wears her thick hair piled on top of her head in the pompadour style. "The Gibson Girl" was the name given to the idealized woman drawn by famed illustrator Charles Dana Gibson. Besides the hair, the look encompassed high collars and pin-tucked and lace-trimmed blouses. President of the club in 1911–1912, Luanna H. Ford wears a simple ensemble that resembles a graduation gown with its clean, simple lines over her sheer white blouse, which appears to have a modesty panel, a piece of fabric at the front of the dress to cover cleavage. These panels have been worn with revealing bodices since the 18th century. Her hair, parted on the side with marcelled waves, appears as an afterthought. (Courtesy of the Rogers Park Historical Society.)

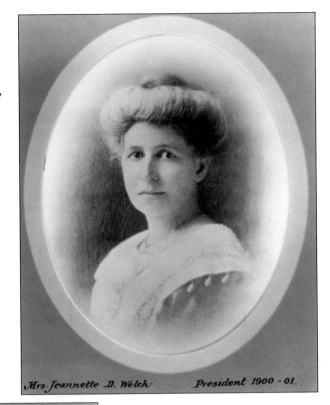

Mrs. Jeannette D. Welch President 1900 - 01.

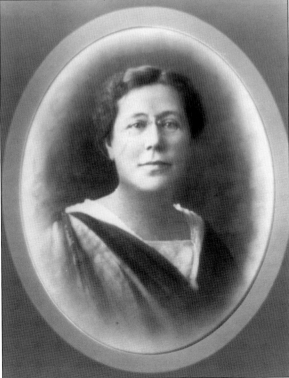

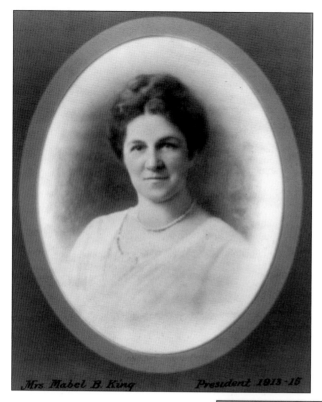

President of the Rogers Park Woman's Club in 1913–1915, Mabel B. King is wearing an outfit popular during the Edwardian period, which some say ended with the sinking of the *Titanic*. King has on a spartan white duster over a lace-trimmed blouse with a scoop neck and a button placket. She has finished off the look with a classic pearl necklace and braid over her center part. Ida M. Hullkorst, president of the Rogers Park Woman's Club in 1915–1917, is wearing the plain kind of dress associated with women on the home front during World War I. Elaborate coiffures and bright colors were out of style; subdued attire, such as Hullkorst's, was proper during a time when nearly everyone knew someone who had died on the frontlines. (Courtesy of the Rogers Park Historical Society.)

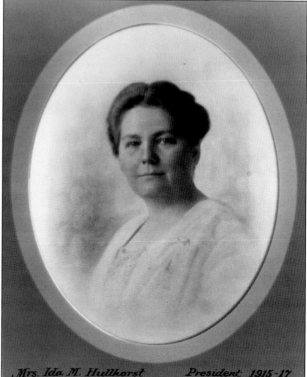

The most daring piece of Alice Gradle's, president of the Rogers Park Woman's Club in 1921–1923, wardrobe is a sheer jacket possibly made from voile or crepe de chine and two necklaces, a look that would become a signature element of the flapper style of the late 1920s. Dresses from the early 1920s had straight lines with a defined waist and a hemline past the knees. Lotion and pinching hair into waves created the popular finger waves of the 1920s, which is possibly how Maude E. Ford styled her white locks for this portrait as president of the Rogers Park Woman's Club in 1925–1927. She is also wearing a lacy dress embellished with a matching frill and a row of buttons down one side of the bodice, as well as a double-strand necklace. (Courtesy of the Rogers Park Historical Society.)

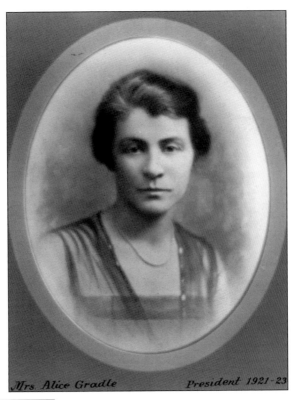

Mrs. Alice Gradle President 1921-23

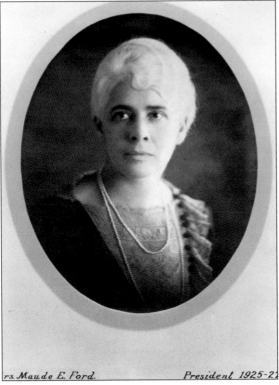

rs. Maude E. Ford. President 1925-27

With her finger-waved hair in place, Annie Foote Wetzel, president of the Rogers Park Woman's Club in 1927–1929, has fully embraced the flapper girl look. She has a scoop-neck dress embellished with cording and embroidery styled in an Egyptian motif, which was hugely popular following the discovery of King Tut's tomb in 1922. Her gold-tone necklace is possibly another influence from the King Tut discovery. (Courtesy of the Rogers Park Historical Society.)

Annie Foote Wetzel *President 1927-1929*

Alice and Wally Carlson pose on a Chicago street corner in this 1931 photograph. Alice is wearing her hair in modified bob, longer than the conventional style, with deep marcel waves likely created using a heated curling iron, a technique named after French hairdresser Marcel Grateau. Women who had their hair styled this way usually kept their curls intact by touching up their waves daily with an iron. (Courtesy of Kay Kuciak.)

Agnes Wells, a member of the Rogers Park Woman's Club, has styled her hair in a way that was popular with older women in 1935—tight curls for bangs and side wisps that vaguely resemble hair swept up into a bun. Coloring hair to cover grey would not become common until the 1950s with the availability of home coloring kits. (Courtesy of the Rogers Park Historical Society.)

Olive B. James's crowning glory was clearly her hair, which is styled here into a series of rolls on each side of her part. This look was popular with both young and older women at the time. It was compatible with contemporary hats, which were tilted and could easily accommodate immaculately coiffed hair. James was a president of the Rogers Park Woman's Club in 1935–1937. (Courtesy of the Rogers Park Historical Society.)

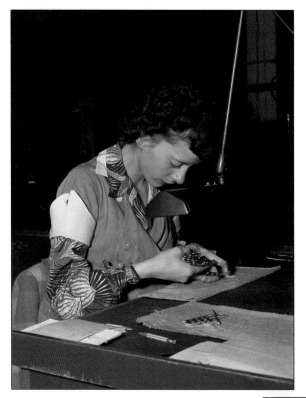

This unidentified young Chicago woman was trained to catch flaws in drills at the Republic Drill and Tool Company in 1942 and might have created her curls using rag curlers, which were strips of fabric rolled up with sections of damp hair and left to set overnight. A setting lotion kept the curls intact. Modern hair spray in aerosol cans would not be available until after World War II. (Courtesy of the Library of Congress, LC-DIG-fsa-8e11169.)

A practical coiffure was the name of the game for Elamaye M. Kerr, president of the Rogers Park Woman's Club in 1943–1945. She poses for a photograph at the Merrill Chase Studios at the Palmer House, a chain started in 1935 by Merrill Chase, who began his career as a Washington, D.C., news correspondent. By the time he passed away in 1987, he was well known as an art dealer. (Courtesy of the Rogers Park Historical Society.)

ELAMAYE M. KERR PRESIDENT 1943 - 1945
Elamaye M. Kerr

Six

FROM BLOOMERS TO PANTS

A woman models a suffragette costume for a Chicago marching parade in June 1916. These pants are very tight around the ankles, making them more akin to a pair of riding breeches than pants worn by men for work. During a time when it was shocking for a woman to even bare her ankles in public, to wear what was considered male garb in daylight was scandalous. This woman does wear a traditional duster with a full peplum in back for additional coverage. (Library of Congress, LC-USZ62-20184.)

SURE!
We'll
Finish
the Job

Gerrit A.Beneker 1918

VICTORY LIBERTY LOAN

With an array of Liberty Loan campaign buttons pinned to his denim bib overalls, an American worker with his sleeves rolled up reaches into his pocket in this 1918 poster produced in Chicago. Pants would become a more prominent part of the working wardrobe for both men and women during World War II. Today Americans often wear a pair of pants, usually denim jeans, to the office. (Library of Congress, LC-USZC4-9651.)

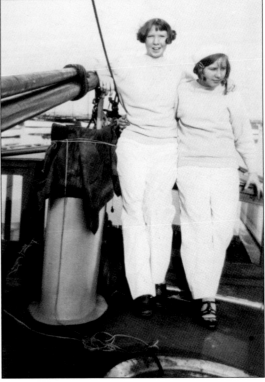

Two women are dressed in matching pants, sweaters, and even bobbed haircuts while sailing on Lake Michigan in 1920. It was acceptable for women to wear pants for sporting activities such as boating, otherwise they were expected to wear skirts and dresses. Movie stars such as Clara Bow and Louise Brooks popularized the bob during the 1920s, a look that was quickly adopted by young girls. (Courtesy of Kay Kuciak.)

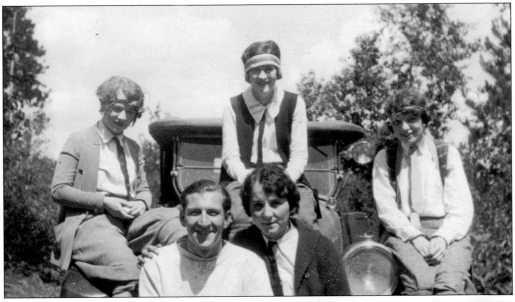

A group of unidentified Logan Square residents sitting on top of an automobile hood are dressed for a ride in the country. The young women are wearing cardigans, ties, and breeches, all traditionally worn by men during 1929. Breeches were acceptable sportswear for women. Butterick sold a breeches sewing pattern in the early 1920s and called them "knickers for ladies, misses and girls." They were appropriate for sportswear, riding, motoring, hiking, and the like. (Courtesy of Tom O'Keefe.)

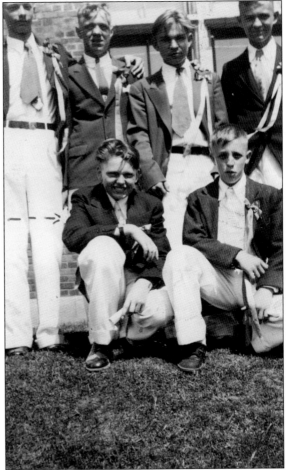

These boys are dressed in their finest for graduation day at Hitch School in the 1930s. Note the exaggerated notch lapels on the suit jackets, a look that was also popular with men and women during this era. White cuffed pants were part of the fashion scene during the Depression; a pair of lightweight cotton pants was also more comfortable in the days before air-conditioning. (Courtesy of Kay Kuciak.)

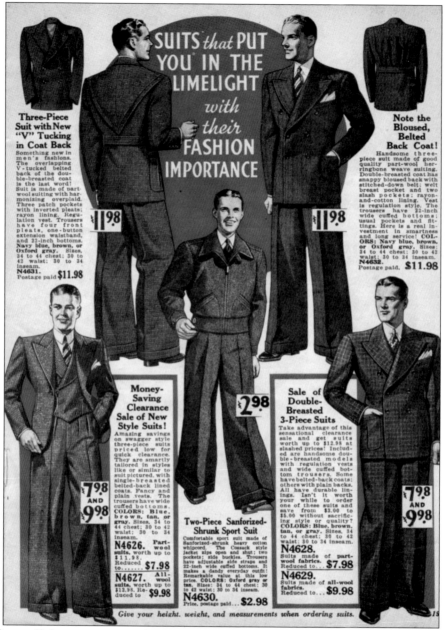

SUITS *that* PUT YOU IN THE LIMELIGHT *with their* FASHION IMPORTANCE

Three-Piece Suit with New "V" Tucking in Coat Back

Something new in men's fashions. The overlapping 'V'-tucked belted back of the double-breasted coat is the last word! Suit is made of part-wool suiting with harmonizing overplaid. Three patch pockets with inverted pleats; rayon lining. Regulation vest. Trousers have four front pleats, one-button extension waistband, and 22-inch bottoms. Navy blue, brown, or Oxford gray. Sizes, 34 to 44 chest; 30 to 42 waist; 30 to 34 inseam. N4631. Postage paid $11.98

Note the Bloused, Belted Back Coat!

Handsome three-piece suit made of good quality part-wool herringbone weave suiting. Double-breasted coat has snappy bloused back with stitched-down belt; welt breast pocket and two slash pockets; rayon-and-cotton lining. Vest is regulation style. The trousers have 22-inch wide cuffed bottoms; usual pockets and fittings. Here is a real investment in smartness and long service! COLORS: Navy blue, brown, or Oxford gray. Sizes: 34 to 44 chest; 30 to 42 waist; 30 to 34 inseam. N4632. Postage paid. $11.98

$11.98 $11.98 $2.98

Money-Saving Clearance Sale of New Style Suits!

Amazing savings on swagger style three-piece suits priced low for quick clearance. They are smartly tailored in styles like or similar to suit pictured, with single-breasted belted-back lined coats. Fancy and plain vests. The trousers have wide cuffed bottoms. COLORS: Blue, brown, tan, or gray. Sizes, 34 to 44 chest; 30 to 42 waist; 30 to 34 inseam. N4626. Part-wool suits, worth up to $11.98. Reduced to........ $7.98 N4627. All-wool suits, worth up to $12.98. Reduced to $9.98

Two-Piece Sanforized-Shrunk Sport Suit

Comfortable sport suit made of Sanforized-shrunk heavy cotton whipcord. The Cossack style jacket zips open and shut; two pockets; side buckles. Trousers have adjustable side straps and 22-inch wide cuffed bottoms. It makes a dandy everyday outfit! Remarkable value at this low price. COLORS: Oxford gray or tan. Sizes: 34 to 44 chest; 30 to 42 waist; 30 to 34 inseam. N4630. Price, postage paid... $2.98

Sale of Double-Breasted 3-Piece Suits

Take advantage of this sensational clearance sale and get suits worth up to $12.98 at slashed prices! Included are handsome double-breasted models with regulation vests and wide cuffed bottom trousers. Some have belted-back coats; others with plain backs. All have durable linings. Isn't it worth your while to order one of these suits and save from $3.00 to $5.00 without sacrificing style or quality? COLORS: Blue, brown, tan, or gray. Sizes, 34 to 44 chest; 30 to 42 waist; 30 to 34 inseam. N4628. Suits made of part-wool fabrics. Reduced to.... $7.98 N4629. Suits made of all-wool fabrics. Reduced to... $9.98

$7.98 AND $9.98 $7.98 AND $9.98

Give your height, weight, and measurements when ordering suits.

Wide-leg, cuffed pants were popular in 1938 sportswear if this advertisement in a Walter Field catalog is any indication. These pants were worn with doubled-breasted jackets or jackets with a back belt, a fad that would last into the late 1940s and eventually disappear. Women also wore similar clothes with the same kind of styling. Wide-leg pants were particularly popular for sports or dancing the Lindy Hop, and they had adjustable side straps. Some also had a strong sailor influence with a buttoned fly front and a high waistband. Fabrics for these trendy trousers included cotton, gabardine, and twill. Sewing pattern companies such as McCall sold wide-leg pant patterns for women. Typically they had no side seams to give them extra fluidity. Side zippers or button plackets were also common elements in these patterns. Sewing machines of the period had special buttonhole attachments to create these plackets. (Author's collection.)

Rose Neudert and her daughter Lorraine are wearing playsuits in the early 1940s during the weekend. These were one of the socially acceptable ways women could wear short pants at that time. Rose's suit has short sleeves, a zipper, and possibly a buckle, while Lorraine's simple halter-top romper was suitable for a toddler. Playsuits such as these could be worn for tennis or a day at the beach. (Courtesy of Lorraine Klatt.)

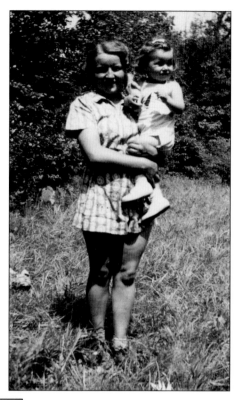

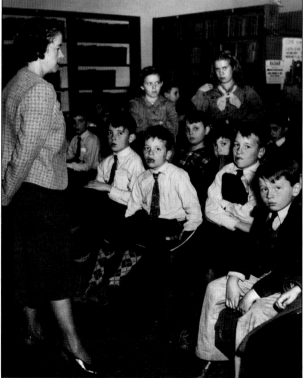

Young children listen to a talk in the early 1940s. The boys are wearing knickers, button-front shirts, and ties; they usually rolled their socks under the edge of their knickers, which had an elastic or a belt fastener. One boy is even wearing a plaid wool jacket, which was also popular with adults at the time. The librarian is wearing a wool jacket with shoulder pads and sling-back shoes. (Courtesy of the Rogers Park Historical Society.)

Chicagoans Emil Kanzer (left) and Art Carlson wear their best suits sometime in the early to mid-1940s. They are both in double-breasted jackets with handkerchiefs in their pockets. Handkerchiefs were useful in the era before Kleenex became common. The men's pants were likely wide-legged and cuffed. Their suits may have been made from part wool, which was cheaper than one with all natural fibers. (Courtesy of Kay Kuciak.)

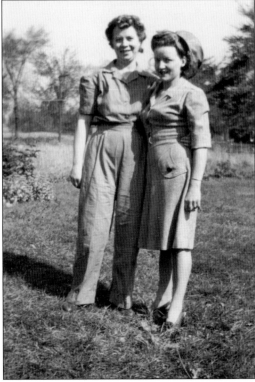

Movie stars such as Katharine Hepburn made pleated pants trendy during the early 1940s. Here an unidentified friend (right) of Chicagoan Rose Neudert (left) wears a pair with a blouse, a feminine touch. Pleated pants during this era were often made with a metal zipper and gabardine, a smooth durable twill-woven cloth typically of worsted or cotton. One drawback to gabardine was it could become dull and shiny with too much pressing. (Courtesy of Lorraine Klatt.)

Seven

TEEN VOGUE

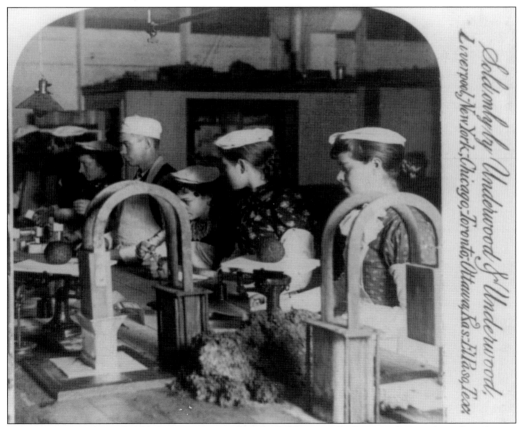

During a time when child labor was unregulated, children worked in an Armour's packinghouse in Chicago, shown here packing and weighing mincemeat at a table. These young girls, probably teenagers, appear to be wearing print dresses underneath their aprons, but their hands are bare. Everyone, male and female, wore pancake-flat white sanitary caps. Mincemeat, a spiced meat, was a popular ingredient in mince pies. (Courtesy of the Library of Congress, LC-USZ62-97454.)

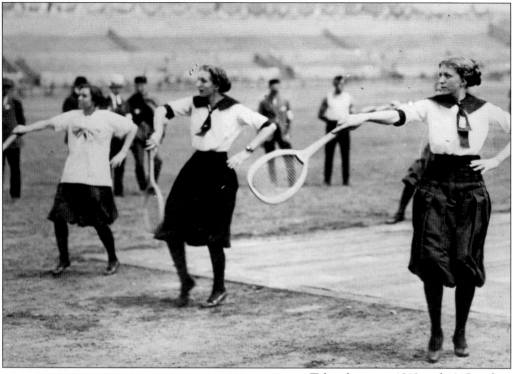

Taken between 1910 and 1915 and titled "Chicago girls at Sokol Sports, Prague, Austria," this unidentified trio wears sports attire consisting of elbow-length blouses, stockings, knee-length skirts, breeches, and slippers. Sokol is a Czech youth and sports movement founded in 1862. Still popular in Czech communities, in the early years it emphasized nationalism and was a precursor to scouting movements. (Courtesy of the Library of Congress, LC-DIG-ggbain-11568.)

Ann Carlson (right) and unidentified friends wear bloomer-style bathing suits, likely wool, at Schurz High School. While the photograph is undated, a handwritten note in script states it was taken during the war, presumably World War I. Carlson has on an early wristwatch, which was introduced in the late 1800s and issued to soldiers in World War I. (Courtesy of Kay Kuciak.)

Fourteen-year-old John Iringle smiles for the Underwood and Underwood camera in 1922 while demonstrating his homemade radio. He is wearing a loose-fitting, striped, elbow-length cotton shirt, which resembles more of what his peers would wear in the 1950s than in the 1920s. Building crystal radios was a typical practice of many teens of the time, as it was the only way to receive news electronically until the invention of the television. (Courtesy of the Library of Congress, LC-USZ62-93539.)

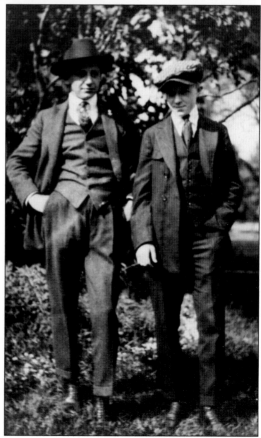

During a time when many boys wore knickers, full-length pants were a way teenagers could differentiate themselves. William Giese (left) and an unidentified friend wear creased pants cuffed at the ankle in 1927. Pants would become wider (called "bags") and slightly longer during the 1930s. The unstructured jacket on Giese's friend was Victorian in silhouette. Men's attire made a transition to a more fitted look during the 1930s and beyond. (Courtesy of Lynn Furge.)

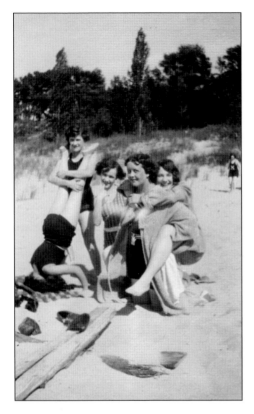

Liberated from the long skirts and bloomers of the previous decade, a group of Logan Square teenagers goofs off on the shores of Lake Michigan wearing figure-hugging, wool-jersey, sleeveless, belted tank suits in the late 1920s. The 1930s would be prove to be a transitional decade for swimwear with the availability of more suitable fabrics. Women's bathing suits would become more feminine and less masculine. (Courtesy of Tom O'Keefe.)

Three unidentified Logan Square friends pose together wearing nearly identical outfits. All three are wearing low-waisted light cotton dresses, one of which is trimmed with the popular Peter Pan collar. They are also wearing square-faced wristwatches, which at the time were fairly expensive. Wristwatches steadily became the timepiece of choice; many were worn on silk ribbons. Later, in the 1930s, many owners switched to chains or bracelets when ribbons lost cache. (Courtesy of Tom O'Keefe.)

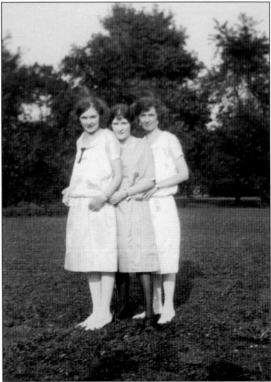

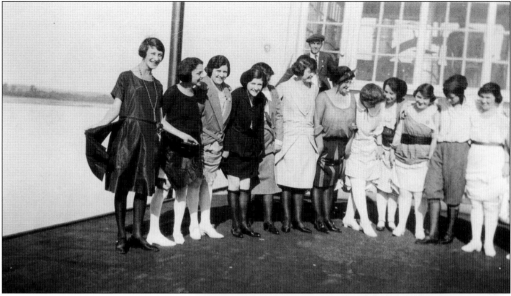

These unidentified young Chicago women in 1929 all have signature elements of the Flapper era: rayon hosiery (silk was more desirable and did not bag at the ankles) and strapped shoes, or Mary Janes (named after the girlfriend of Buster Brown, a trademarked character of the Brown Shoe Company in 1904). The woman on the left captures the look of the era with her dress, which has trumpet-shaped frills. (Courtesy of Tom O'Keefe.)

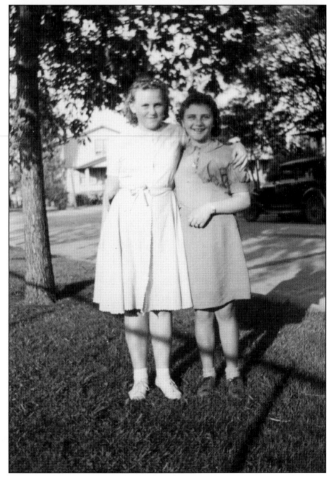

Best friends forever in the 1930s, Irene Ross Fransen (left) and an unidentified pal both wear puffy short-sleeve cotton dresses, socks, and laced-up shoes suitable for playing outside. Fransen's friend appears to be wearing a dress with a short zipper at the collar; zippers became more widespread during the Depression and later. Early zippers were made of metal, making them heavy and cumbersome. (Courtesy of Kay Kuciak.)

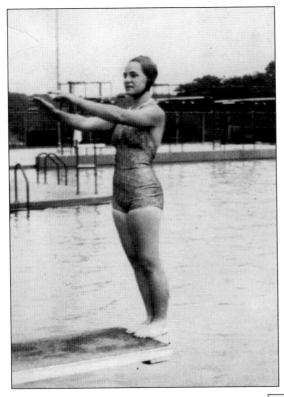

Janet Carlson gets ready to do a backward dive at Whalen Pool in Chicago in 1936 wearing a bathing cap and swimsuit, which is cut so that the wearer can swim more freely and get a tan easily. In 1936, Jantzen would produce a line of "glamour" swimsuit fabrics; a local lithographer produced an advertisement touting this invention in 1939. (Courtesy of Kay Kuciak.)

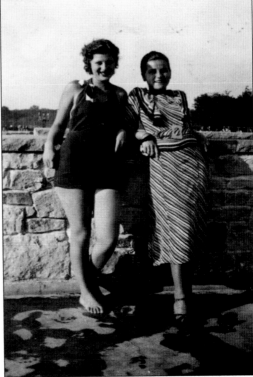

Janet Carlson (right), dressed in a sassy blouse and skirt embellished with a buckle, relaxes as she poses with an unidentified friend dressed in a halter-style playsuit at Whalen Pool in Chicago. The playsuit combines shorts, a skirt, and a backless bodice. Carlson's friend could easily run on the beach barefoot and get a suntan at the same time. The two women worked at the pool during high school. (Courtesy of Kay Kuciak.)

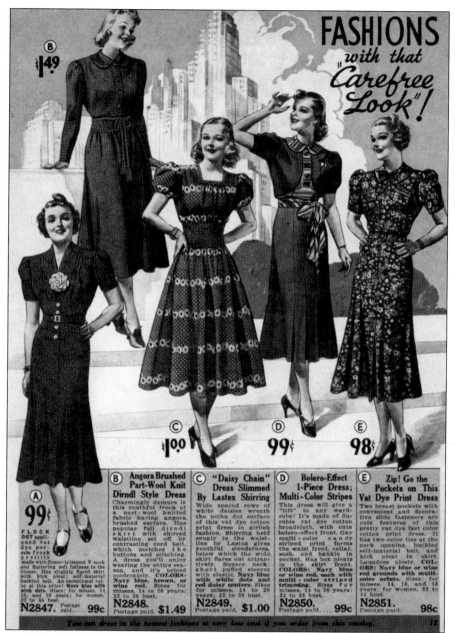

Catalog Walter Field and Company in Chicago targeted teenage girls with disposable income during the Great Depression. While sewing was a valuable skill, there was a growing market for ready-to-wear clothing for fashionable teens pressed for time. Teens were encouraged to get that "carefree" look at a low cost with any of the dresses, most of them with flared or dirndl skirts. Any shirring on the bodice was achieved with elastic thread, called Lastex, as opposed to a natural-fiber thread during the late 1800s. Zippers, known as slide fasteners, were also available in most ready-to-wear garments in the late 1930s. Most teenage girls wore bras and panties during the late 1930s. Bias-cut, full-length slips underneath dresses and skirts were also a must; however, young women did not want their slips showing underneath their outfits. Any skirt or dress was generally worn with pumps for a night out on the town or church. (Author's collection.)

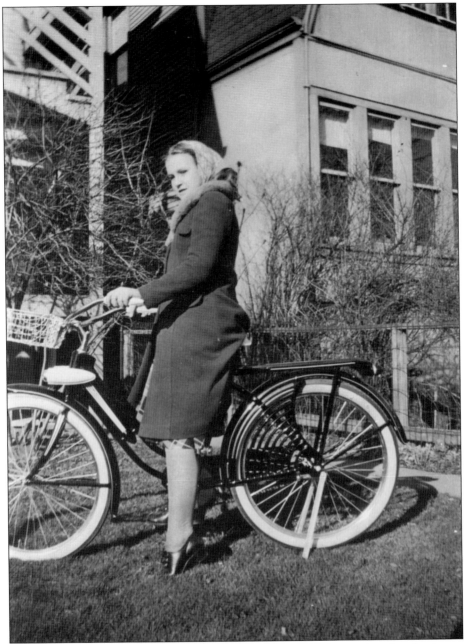

Chicagoan Irene Carlson, bundled up against the cold in 1940, is wearing the classic cover-up for Chicago teenagers—a scarf and wool coat with a fur collar over a plaid skirt—to show off her bicycle in front of her family's Gladstone Park home. Her bike resembles the "Girl's Finest Deluxe Equipped Elgin" sold by Sears, Roebuck and Company with the distinctive airstream frame. It also came with a skirt and chain guard, a device that fits over the rear wheel to prevent a skirt or long coat from getting caught in the wheel. This particular model was the most expensive one in the 1941 catalog at $36.95, a worthwhile investment in many teens' minds. Many of them rode their bikes to school daily during World War II to collect metal for special drives. Carlson still had the bike as late as 2000. (Courtesy of Kay Kuciak.)

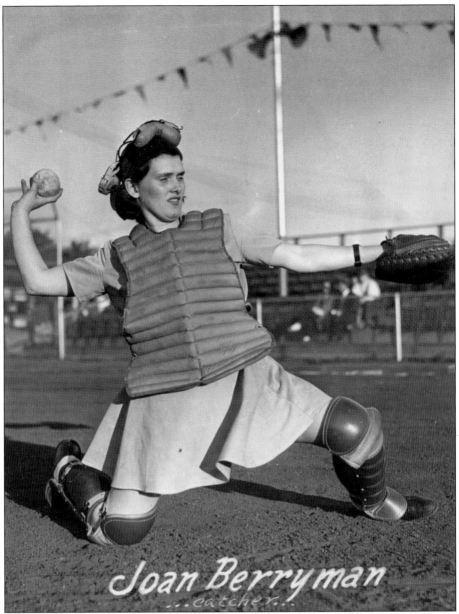

Joan Berryman
...catcher...

Northtown Co-eds catcher Joan Berryman poses in mid-throw in the 1940s at Thillens Stadium in Chicago. Women wore skirts in nearly all sports—ice skating, roller skating, tennis, and baseball—although there were some exceptions. Women in the National Girls Baseball League wore uniforms consisting of shorts or knickers. Teens at Taft High School during the 1940s were allowed to wear breeches for horseback riding at nearby stables. Sears, Roebuck and Company sold high-waisted jodphurs, breeches, and western-style pants for women in a 1941 catalog. While women's denim riding jeans and saddle pants in denim or cotton twill were also sold through the Chicago-based company, they only sold baseball uniforms for boys and men. Mass-manufactured sports uniforms for the opposite sex were still decades in the future. Women playing baseball and softball were still considered somewhat of a novelty. High-tech wicking fabrics specifically for sports attire in general were also yet to be invented. (Courtesy of the Rogers Park Historical Society.)

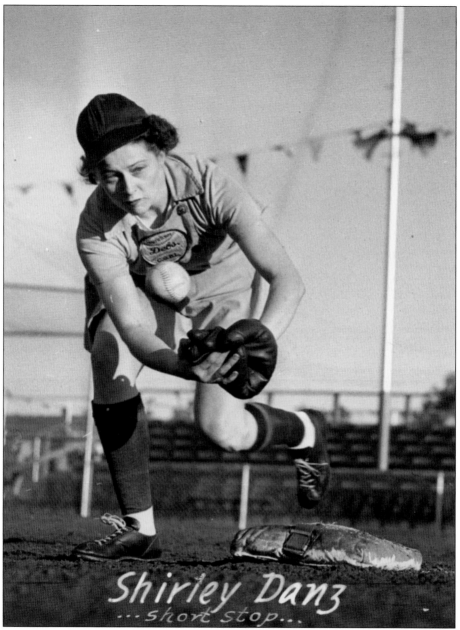

Shirley Danz
...short stop...

T-shirt uniforms for athletic young women were still decades away as shortstop Shirley Danz of the Northtown Co-eds gets ready to throw the ball in the 1940s. The uniform top at the time was a double-breasted buttoned blouse with the team's emblem stitched on the front. The blouse was similar to what factory workers wore during World War II. The Co-eds played against many teams until the league dissolved in 1954. Joan Berryman would later play for the Chicago Colleens, a women's professional baseball team in the All-American Girls Professional Baseball League, which was organized in 1943. The league was later the inspiration for *A League of Their Own* starring Madonna and Rosie O'Donnell. Costume designers modeled costumes for the cast and extras based on vintage photographs from this period. The movie was filmed at Wrigley Field and other Chicago locations. (Courtesy of the Rogers Park Historical Society.)

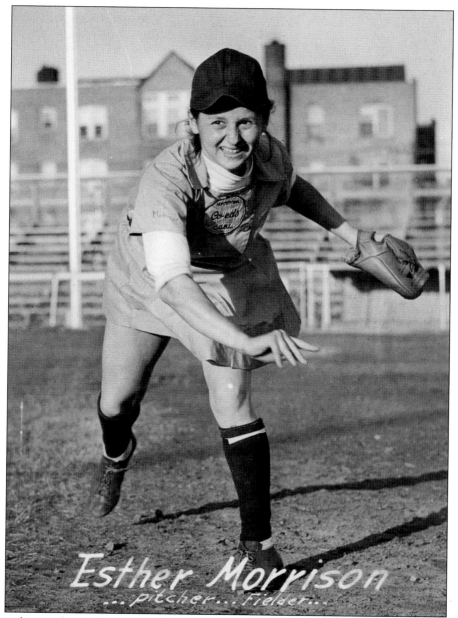

Esther Morrison
...pitcher...Fielder...

Wearing lace-up leather shoes and heavy dark socks, Northtown Co-eds pitcher Esther Morrison is caught in action on the field at Thillens Stadium in the 1940s. She was probably wearing black cowhide shoes made for men. Sears, Roebuck and Company sold several varieties in 1941; the most expensive pair was $3.69. Sports shoes specifically for women were still decades away. Morrison appears to be wearing a women's turtleneck top underneath her uniform tunic, perhaps to fight off the chill. Sears also sold men's cotton rib-knit undershirts for 59¢ each in the baseball section of its catalog. Cotton-backed rayon satin caps were also available. Morrison has creased her baseball cap, which she no doubt did to imitate her male counterparts. The one-size-fits-all baseball caps of the period had an elastic band in the back. Thillens Stadium, now operated by the Chicago Park District, continues to be used for softball games. (Courtesy of the Rogers Park Historical Society.)

Mary Locashio
... pitcher...

Mary Locashio, pitcher for the Northtown Co-eds, is wearing a uniform dress in the 1940s during a game at Thillens Fields. Women who tried playing baseball in the early 1900s had to wear skirts over their bloomers; this extra layer severely restricted movement. Later players simply wore the bloomers, not a uniform like their major-league male counterparts. Chicago Cubs owner Philip K. Wrigley, founder of the All-American Girls Professional Baseball League, was not interested in bloomers for his female players in 1943. He mandated shorter skirts because he figured the crowds would like it. Consequently, minor-league teams such as the Co-eds also wore similar skirts, which were supposed to be no more than six inches above the knees; this regulation was difficult to follow. Interestingly, the uniform dress had a belt, which would be considered a hindrance for today's sports activities. (Courtesy of the Rogers Park Historical Society.)

Tippy Schweigert

Tippy Schweigert, a player for the Northtown Co-eds, keeps her curls intact underneath her baseball cap. Most women participating in team sports continued to style their hair prior to games in the 1940s, copying their peers in the All-American Girls Professional Baseball League where styled coiffures were a requirement. Players traveled to their games with beauty kits and hairbrushes, freshening up before practice in restrooms. Major-league players were expect to carry cleansing cream, rouge, and other cosmetics while they were on the road. Shoulder-length, curled hair was ideal, although some women would wear braids tied with rubber bands for the games. Pixie cuts for women were still at least a decade away, and casual, straight ponytails tucked beneath ball caps would not become more widespread for years. Women who wanted shorter dos often went to the barber to get the job done. (Courtesy of the Rogers Park Historical Society.)

Elaine Wyse
...Pitcher...

Northtown Co-eds pitcher Elaine Wyse is caught in action on film in the 1940s at Thillens Field, which was built in 1938 by Mel Thillens. The field was on a lot near the intersection of Devon and Kedzie Avenues. Northtown Currency Stadium, which was later renamed for its founder, drew crowds east and west of the Sanitary District Canal. During World War II, a group of men, which included Cubs owner Philip K. Wrigley and his colleagues, organized the All-American Girls Professional Baseball League when they learned that major-league baseball season might be put on hold due to the shortage of male players. Women tried out for the team at Wrigley Field. Short hair, jeans, short skirts, makeup, and physical attractiveness were a part of the dress code. The Northtown Co-eds were part of a four-team minor league in Chicago called the Chicago Girls Baseball League. (Courtesy of the Rogers Park Historical Society.)

Eight

MARY JANES AND BUSTER BROWNS

Four boys are dressed in their finest white shirts, caps, bow ties, knickers, socks, and shoes at the World's Columbian Exposition in 1891 or 1892. Notice they are wearing belts instead of the traditional suspenders, possibly because attending the Exposition was a special event. One boy is also promoting Quaker Oats, an employer that remains in Chicago today. (Courtesy of the Library of Congress, LC-USZ62-104793.)

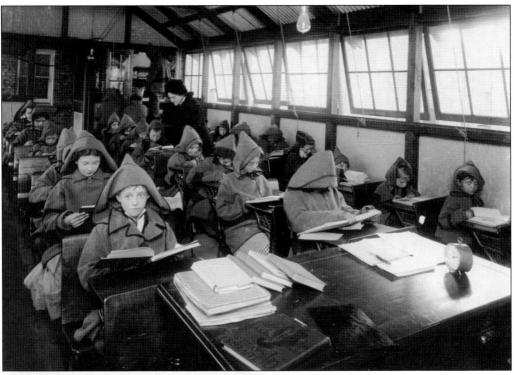

Pupils read books while wearing unisex, hooded wool coats trimmed with contrast piping to keep warm on the enclosed roof of the Mary Crane Nursery while their similarly bundled-up teacher oversees her class. During the early 20th century, particularly 1900 and 1920, cold air was thought to keep germs and tuberculosis at bay, hence the open windows. (Courtesy of the Library of Congress, LC-DIG-ppmsca-18483.)

Two unidentified young boys with clothes typical of the early 1900s are shown at left. One boy (standing) sported a long skinny tie and possibly a miniature version of the masher collar, the extremely high collars worn by men in the late 1800s and early 1900s. Masher was slang for a sexual predator. They sometimes affected the high collar to resemble a clergyman. (Courtesy of Kay Kuciak.)

In 1905, an unidentified daughter of Marshall Field, the founder of the department store of the same name, wears what appears to be a white cotton elbow-length dress accentuated with scalloped eyelet trim at the hem and embellished with pintucks on the bodice. She is barefoot, which was unusual. This could have been a genre photograph where she was posing as a young girl of the streets. (Courtesy of the Library of Congress, LC-DIG-ggbain-00627.)

Siblings Marie and William Giese wear their best attire in 1908. The ruffle-trimmed collar on Marie's heavy white dress, which she wears with dark stockings and matching buttoned shoes, resembles the falling band, a large, flat, turn-downed collar worn by both men and women from 1570 to 1670. Her brother dons a striped peasant's shirt, matching shorts, stockings, and laced-up boots, attire typical of recent immigrants. (Courtesy of Lynn Furge.)

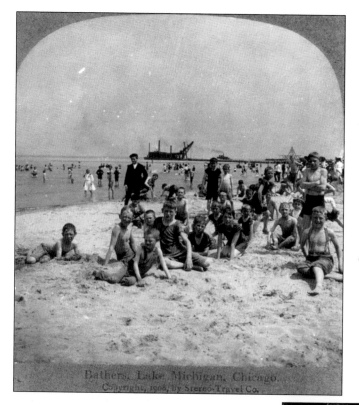

Swimming in Lake Michigan was a way to cool off in the days before air-conditioning in Chicago. Children in 1908 are sporting a variety of swimwear, including knickers with suspenders and striped suits, all likely made with cotton or wool. Their attire resembled what men wore to swim. Girls often wore bloomers or cooled their heels while wearing street clothes like the girl in the white dress is doing in the background. (Courtesy of the Library of Congress, LC-USZ62-61670.)

Kay Kuciak's husband's unidentified grandmother poses for a photograph following her eighth-grade graduation from an unknown Chicago school probably in 1910. The eighth grader is dressed head to toe in white with a big bow to match her diploma and a ribbon pinned on her lapel to mark the occasion. A bracelet is also visible on her wrist. (Courtesy of Kay Kuciak.)

This young girl, Helen Morton of Chicago, is at a 1914 Washington horse show, where she poses with her greyhound. She has drawn her inspiration from the men with derbies and panama hats by wearing an outfit with a masculine theme: a three-piece suit with a skirt instead of pants. She is even wearing a tie, blouse, and a hat similar to those worn by passersby. (Courtesy of the Library of Congress, LC-DIG-npcc-27873.)

In 1917, Irene (left) and Esther Giese wear the typical hair styles (short hair and bangs topped with wide-ribbon bow) and outfits of the day, consisting of gauzy white cotton dresses with elbow-length sleeves and matching socks and shoes. The Chicago sisters later played in an all-girl band to support the family during the Depression. (Courtesy of Lynn Furge.)

Holding a small stuffed animal, Ann Carlson is wearing a special-occasion dress and buttoned boots while standing on an ornate wicker chair in 1918 or 1919. Her naturally straight, fine hair has been left untouched for this photograph. Most young girls had their hair styled for these pictures. The wicker chair was especially noteworthy; it could have been made in Chicago, which had a robust wicker furniture industry. (Courtesy of Kay Kuciak.)

Walter Kasm, in this 1918 St. Adalbert's graduation photograph, appears to be second from the right in the second row of boys. The Roman Catholic priest in the center is wearing the conventional cassock surrounded by girls in middy dresses, which are most well known by their Big Bertha collar (named after the Kaiser's daughter, who also gave her name to Germany's biggest cannon in World War I) and sailor-style scarf. (Courtesy of Kay Kuciak.)

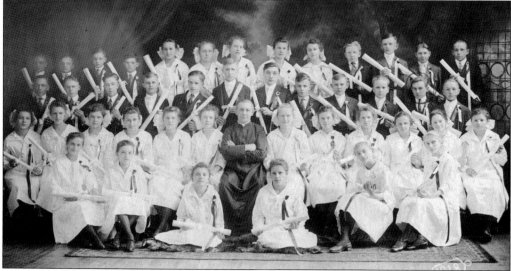

Janet Ross, age 4, standing on a wide Chicago sidewalk with an elevated rail line in the distance, is wearing a drop-waist dress with a Peter Pan collar for this 1920 photograph. The simple details, a corded outline stitched on the bodice and bows at the hips, were distinctive of 1920s attire. The striped socks and Mary Janes were also typical of what children wore in the 1920s. (Courtesy of Kay Kuciak.)

A group of Polish immigrants has gathered for this 1924 photograph in Americanization class at the Rogers Park Woman's Club. The woman in the middle, possibly the teacher, stands out with her attire. The rest, adults with their children, are wearing clothes that look like they would have been at home in Eastern Europe with belted buttoned tunics for the boys and loose smock dresses for the girls. (Courtesy of the Rogers Park Historical Society.)

Rogers Park resident Charna Kohn wears a loose dress with a Peter Pan collar and an arts and crafts–style motif on the bodice and sleeve for this 1925 photograph. Wrights sold educational leaflets during this period that showed home sewers how to embellish their garments, children's in particular, with inexpensive bias tape, which was available in solid colors and prints. The double-fold strip of fabric, sold in packages at department stores and catalogs, could be twisted and shaped in vines and flowers on a dress bodice and used as a ruffle or piping on a Peter Pan collar. The particularly skilled sewer could add fagoting, a type of stitching in which the threads are bundled together. To top off her look, Kohn had a ribbon around her head just like the flappers did. Boys during this period wore simple serge, flannel, and tweed suits, with shirts that resembled their elders. (Courtesy of the Rogers Park Historical Society.)

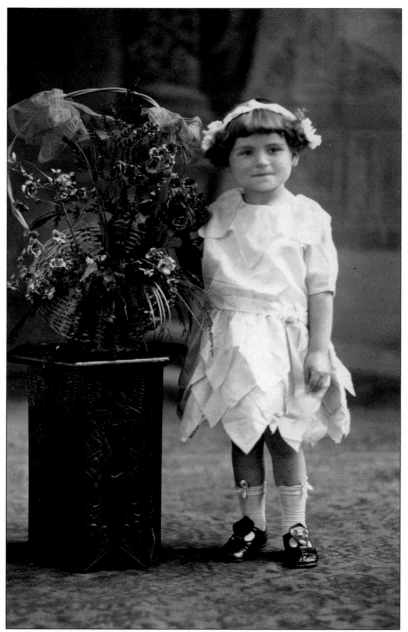

Janet Ross, age 5, poses next to a stand probably made during the arts and crafts movement, which flourished between 1880 and 1910. It influenced architecture and home design. Chairs, tables, beds, and other furnishings of this period were marked by the characteristic scrolls, vines, and leafs. Ross wears a dress that also takes its cue from nature from the petal collar to the leafy-shaped hem. It was an outfit that was vaguely reminiscent of Peter Pan, a fictional character who wore an outfit of autumn leaves and cobwebs; Peter Pan was a central character in a popular 1924 silent film by the same name. This nature theme was also popular in women's clothing during the mid-1920s. Variations included a black-and-gold lace evening dress with a petal-shaped hem. Women, particularly brides, and girls during this period also wore flower-trimmed headbands just as Ross did for her picture. (Courtesy of Kay Kuciak.)

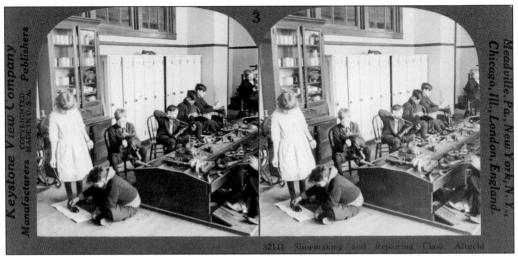

Young children at Altgeld School, on Chicago's South Side, take a shoe-making and repair class in 1929, undoubtedly a skill that would come in handy during the Depression. Here a boy measures a girl's foot. They are both wearing typical school attire: she in a knee-length dress with matching dark socks and shoes and he in a dark jacket and knickers. (Courtesy of the Library of Congress, LC-USZ62-107067.)

The Hitch Grammar School orchestra poses on the steps during the late 1920s for a graduation photograph. This was a transition period for boys' trousers; some boys wore pants, while others wore breeches, which paved the way for the time when nearly all young boys wore pants by the late 1940s. Serge, twill, gabardine, and corduroy were some of the durable fabrics used to make these garments. (Courtesy of Kay Kuciak.)

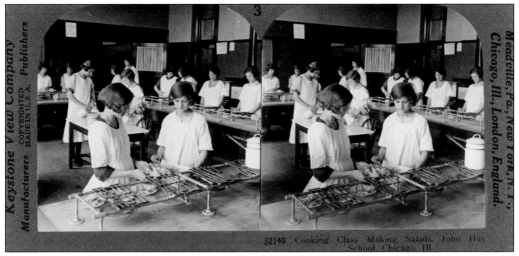

32140 — Cooking Class Making Salads, John Hay School, Chicago, Ill.

These young girls are in a cooking class at John Hay School, named after a former U.S. assistant secretary of state during President Lincoln's administration. They both are wearing smocks over their dresses as they learn how to prepare salads. They both have short bobbed hair, a style that was popular with children and adults in 1929 when this stereograph was made. (Courtesy of the Library of Congress, LC-USZ62-107068.)

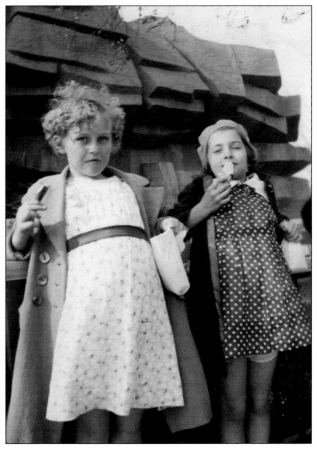

Irene Ross (left) and an unidentified friend casually pose for a photograph shot at the Lincoln Park Zoo sometime in the 1930s. They are wearing their best dresses, coats, shoes, and socks for this event. Ross's friend is wearing an organza polka-dot dress over a slip. Polka-dot prints of all varieties were popular during the Depression; they were thought to be cheery during a time when many Americans were out of work. (Courtesy of Kay Kuciak.)

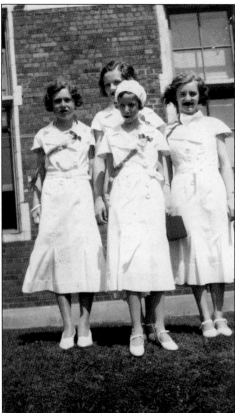

Four young girls, including Janet Ross, look cheerful following eighth-grade graduation at Rufus M. Hitch School, which was named for a superintendent of schools on Chicago's Northwest Side. These Chicago graduates are wearing matching white double-breasted shirtwaist dresses cinched with belts and buckles, a popular Depression-era style. Sears, Roebuck and Company and other department stores sold kits with matching buttons and buckles. (Courtesy of Kay Kuciak.)

With his sleeves rolled up, an unidentified young male friend poses for a photograph with Janet Carlson around 1935 in a grassy field on a sunny day. Carlson appears to be wearing an adult's cap on her head and a lightweight dress with a subtle white-on-white striped print. Her hair is also cut boyishly short, vaguely reminiscent of the hairstyles in the *Little Rascals* film series. (Courtesy of Kay Kuciak.)

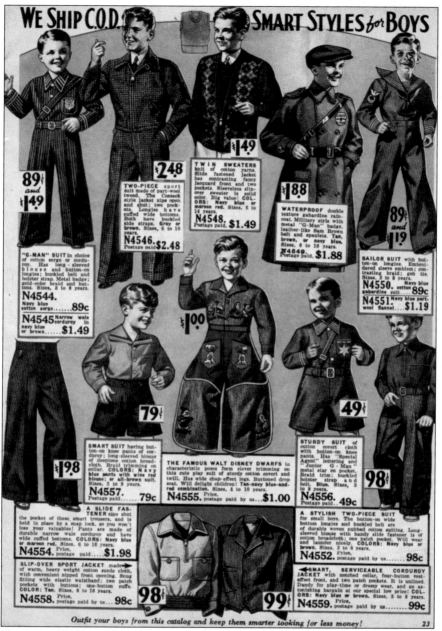

Outfit your boys from this catalog and keep them smarter looking for less money! 23

The influence of Hollywood and the U.S. government was prevalent in children's clothing in 1938. *Snow White and the Seven Dwarfs* made its debut in 1937, and a year later the cartoon characters of the dwarfs adorned a boy's playsuit. James Cagney, in the 1935 movie *G-Man*, no doubt influenced the Walter Field suits and raincoat that had a G-Man badge, Sam Browne belt, and epaulets. These accessorized child-sized outfits mimicked those worn by real-life federal agents in the 1930s. Children would play with toy Tommy guns for hours and wear tin badges, imitating what they saw on the movie screen. Boys' underclothes were not commercialized yet. During the winter, they wore plain one-piece cotton and wool union suits, which Walter Field also sold. While the now-defunct catalog house was located in Chicago, Walter Field had customers as far away as San Francisco. (Author's collection.)

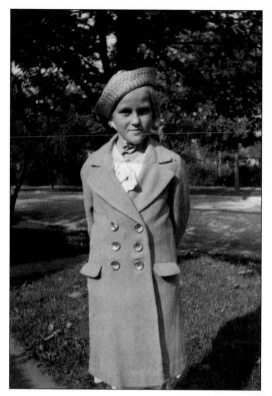

Double-breasted wool coats were commonly worn by children and adults alike, and it continues to be a classic look, especially for special events like holidays, first communions, weddings, and funerals. In 1939, Irene Ross is wearing her coat over a dress with a straw, sailor-style hat perched off-kilter on her bobbed hair while posing for a picture in front of her grandparents' Chicago home. (Courtesy of Kay Kuciak.)

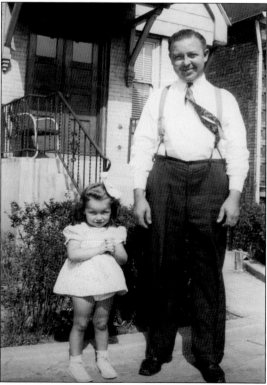

Lorraine Neudert poses with her father, Richard, in front of their Humboldt Park home during the early 1940s. Lorraine is wearing a short-sleeve dress often worn by toddlers during the early part of World War II. Her hair is tied back in a big bow, vaguely reminiscent of child movie star Shirley Temple, who would wear her hair in ringlets of a similar style for her early roles. (Courtesy of Lorraine Klatt.)

Nancy Furge poses with an adult hat on her head, a style that was popular in the middle of the 1940s. The brim flares outward and upward with no embellishment. Many hats of this era were simple and unadorned, reflecting the austerity of the times and fabric rations. Girls' hats during this period mirrored what their mothers wore, which were tyrolean pork-pies, pillboxes, tams, and bonnets, either in a pedaline braid for spring and summer or wool felt for fall and winter. Furge's dress with puffy sleeves was typical for the period. Sears, Roebuck and Company sold a variety of this same type of dress, all with popular girl's names: Doris, Lucy, Polly, Betty, and Patty. Only the nautical-themed "Clara" had wide-leg overall slacks with a complementary smock-style, short-sleeve jacket. Young girls such as Furge probably wore one-piece cotton underwear. Older girls wore vests, panties, or bloomers with a full-length slip. Furge lived on Menard and Irving Park Roads, where the Blue Line elevated rail line now exists. (Courtesy of Lynn Furge.)

www.arcadiapublishing.com

Discover books about the town where you grew up, the cities where your friends and families live, the town where your parents met, or even that retirement spot you've been dreaming about. Our Web site provides history lovers with exclusive deals, advanced notification about new titles, e-mail alerts of author events, and much more.

Find Your Place in History.